The Mike DUBISCH Sketchbook Volume one

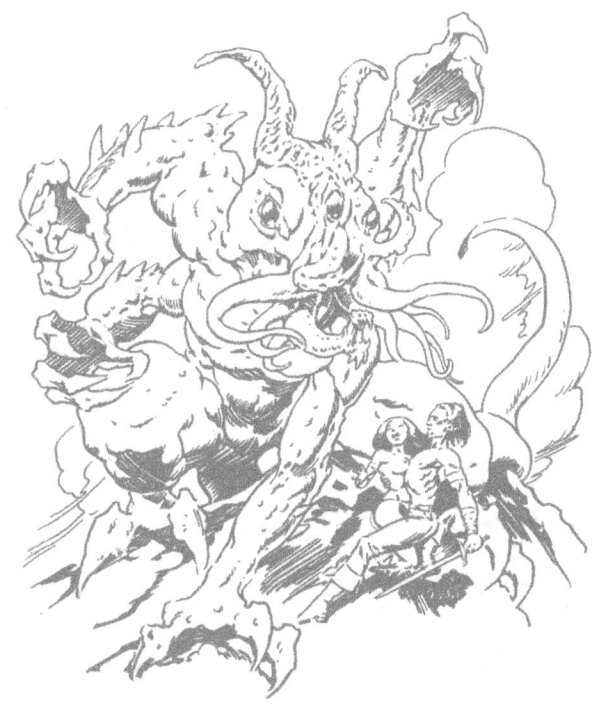

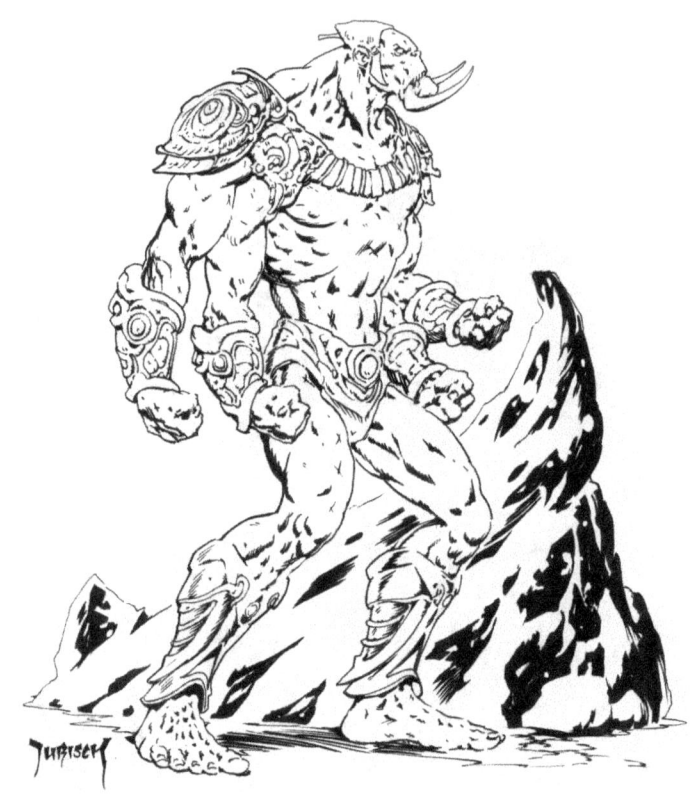

The Mike Dubisch Sketchbook Volume One
© Mike Dubisch
Published by Mike Dubisch

All characters and worlds depicted are
copyright and trademark their respective copyright holders.
No portion of this book may be reproduced in any form without
permission from the publisher, unless it is for
the purpose of review.

The Mike Dubisch Sketchbook series is a review of past
and current sketches and drawings by artist/creator
Mike Dubisch.

Published on Earth

THE MIKE DUBISCH SKETCHBOOK VOLUME ONE

DUBISCH

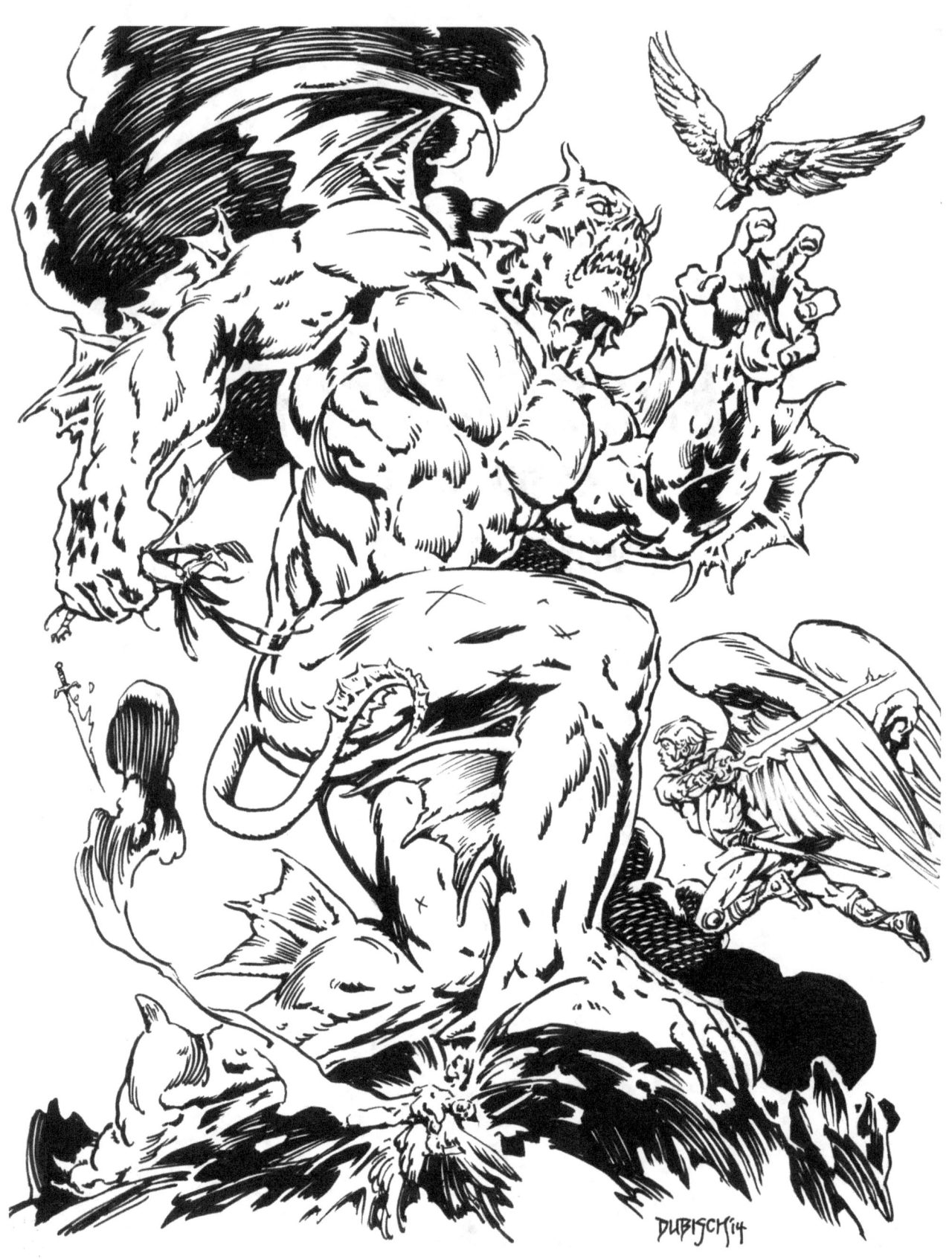

Welcome to the first volume of the Mike Dubisch Sketchbook Series.

These volumes compile the best and most elaborate of my drawings, sketches, and black and white illustrations from the last few years.

In addition to personal work, sketchbook play, and preliminary drawings for a variety of book and magazine covers, some art for various Shannon Eric Denton graphic novels, multiple H.P. Lovecraft commissions, and projects with my author friend Cody Goodfellow.

Keep an eye out for tributes to the great french cartoonist Moebius, both overt and otherwise.

I've also included some of the art and preliminary phases of my work on cd and album covers, a little film development work, and some unpublished card game art. Finally, I've thrown in some favorite pieces from my doodle book, a special sketchbook I keep and carry to pass the time, drawing directly with a pen or marker.

I hope you enjoy this selection of images.

Mike Dubisch, 2015

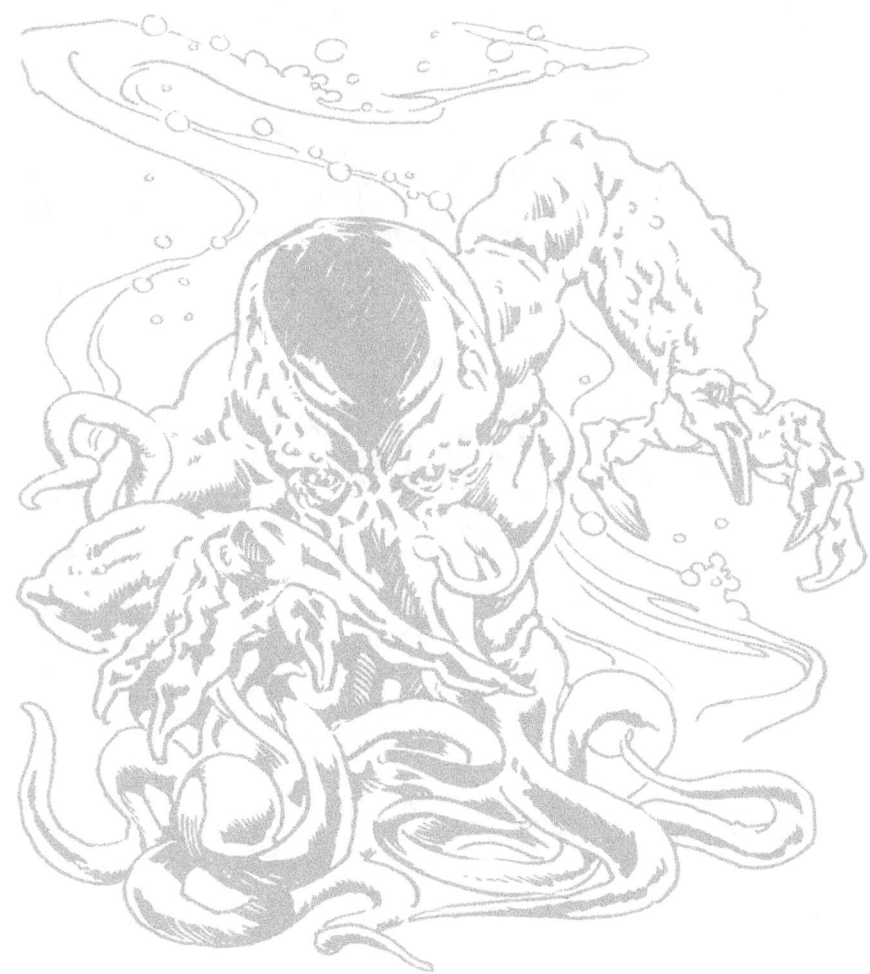

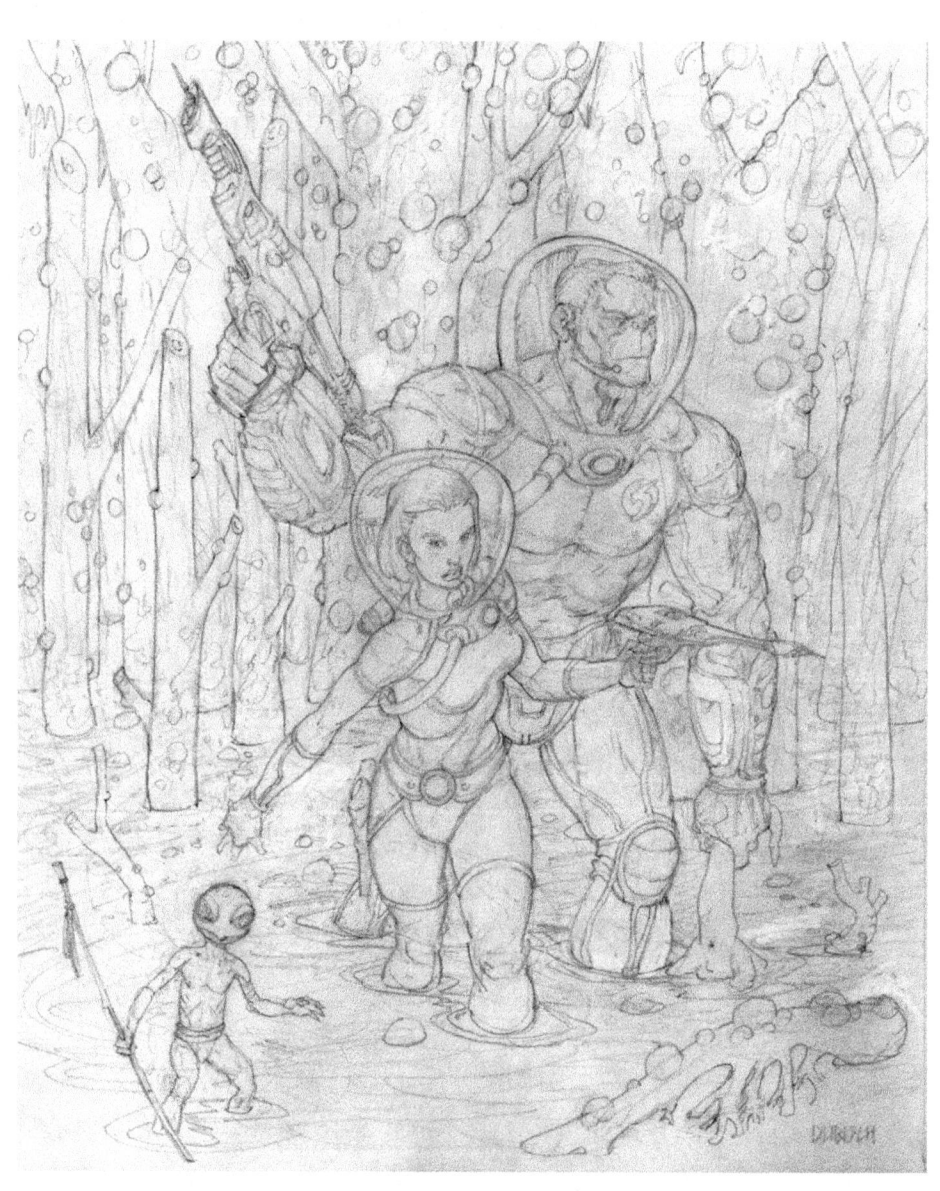

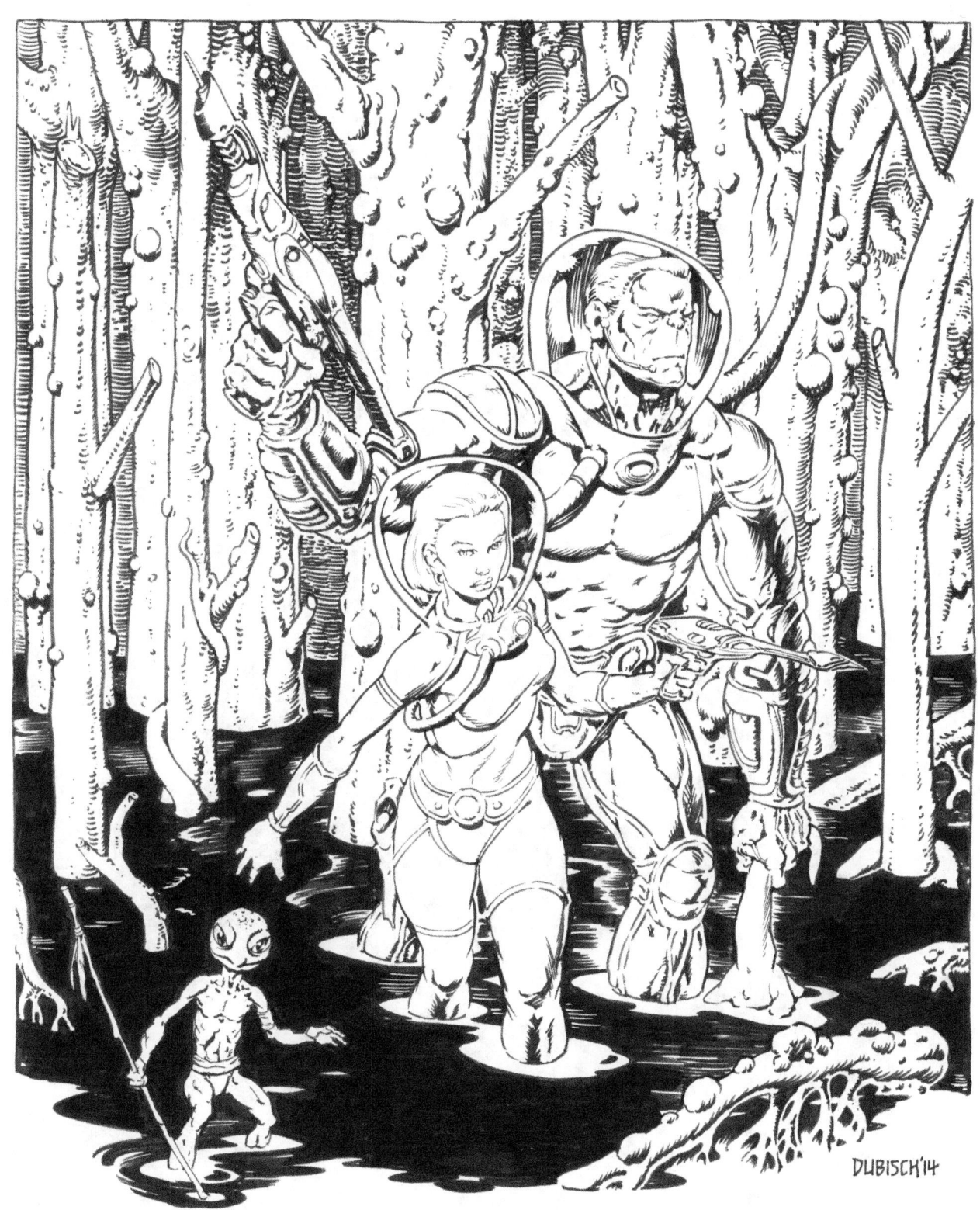

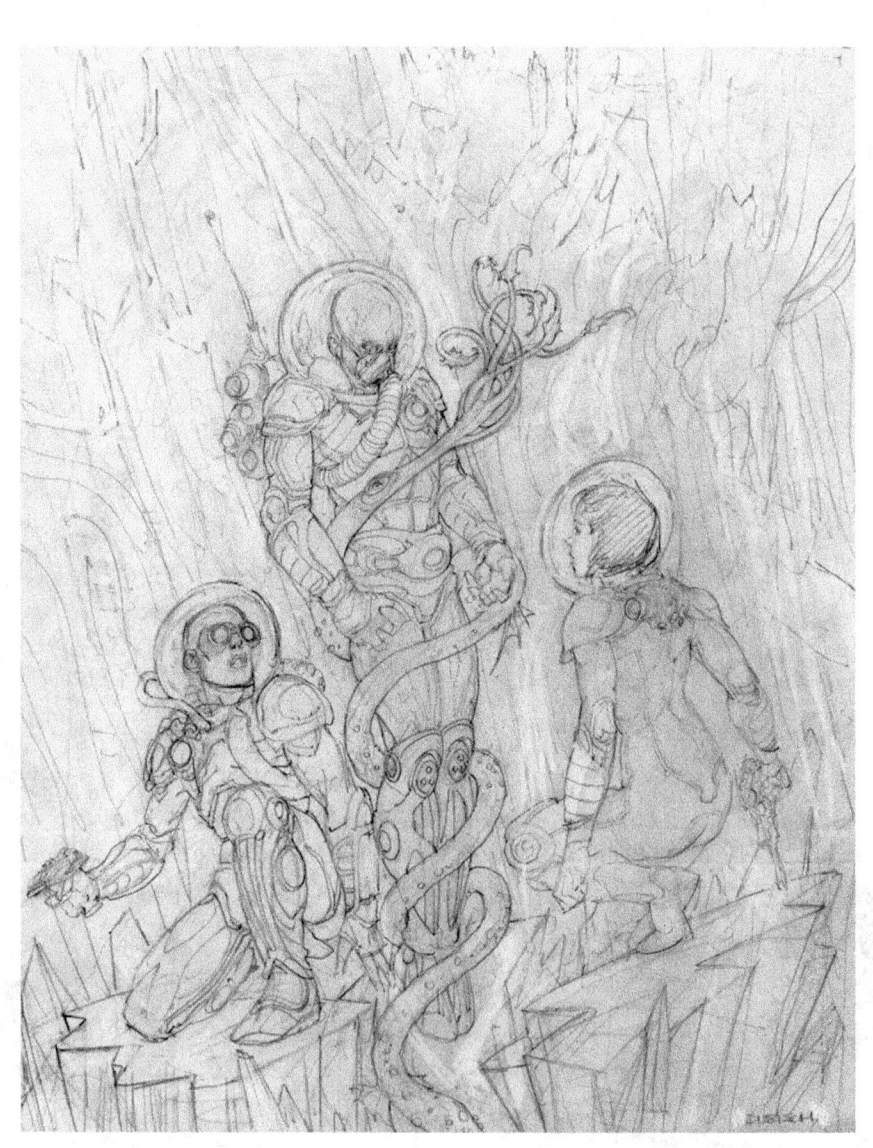

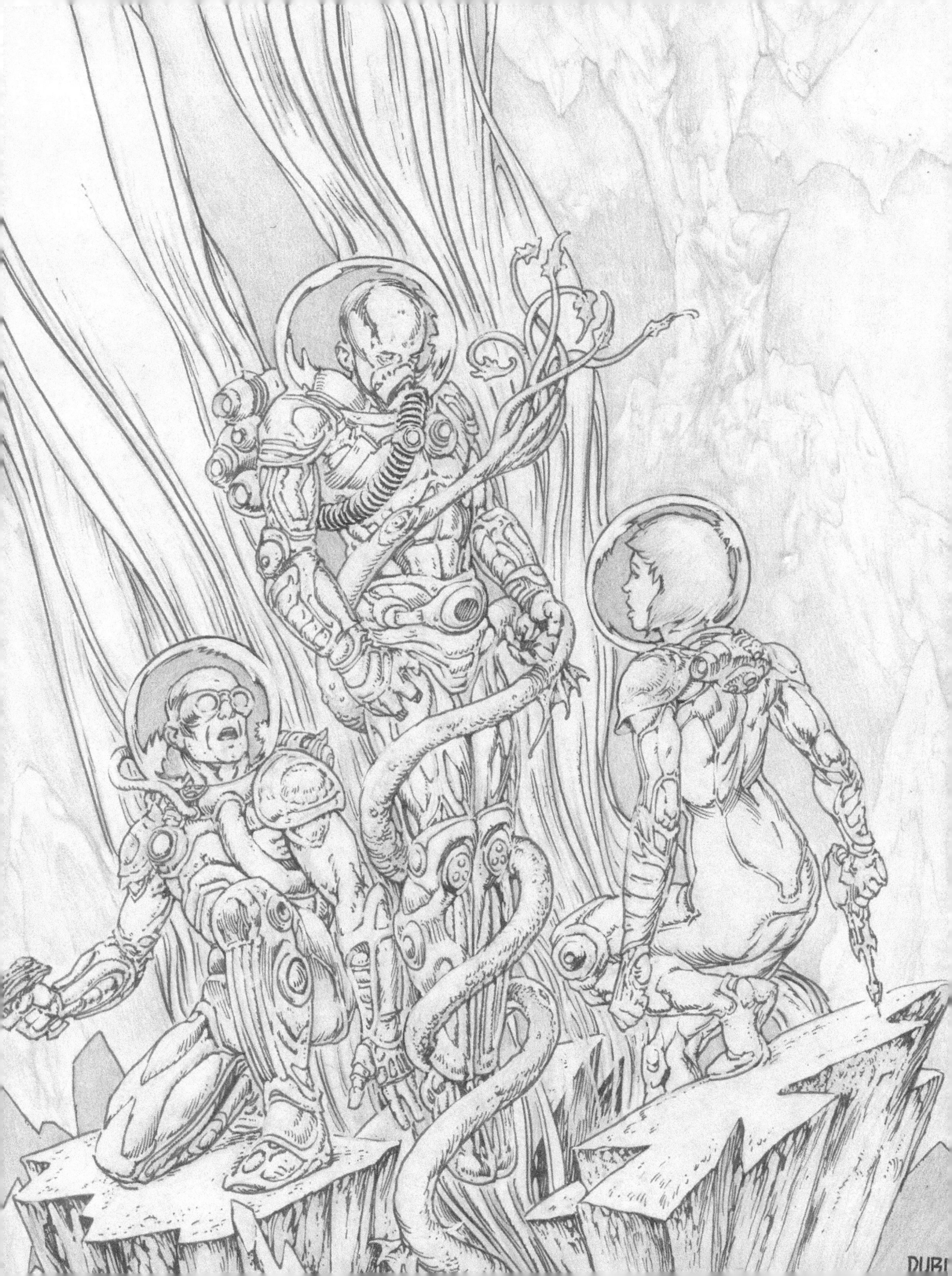

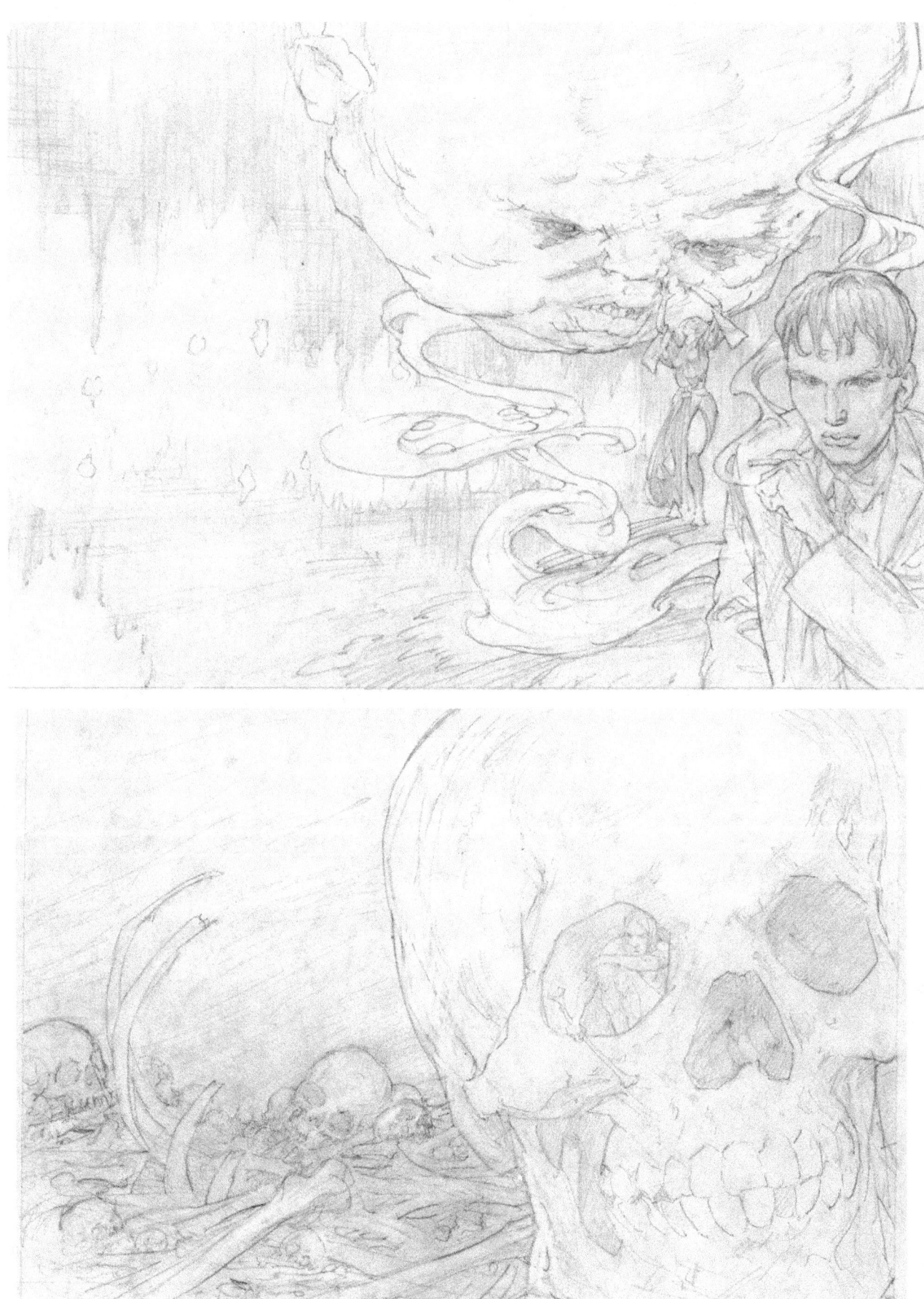

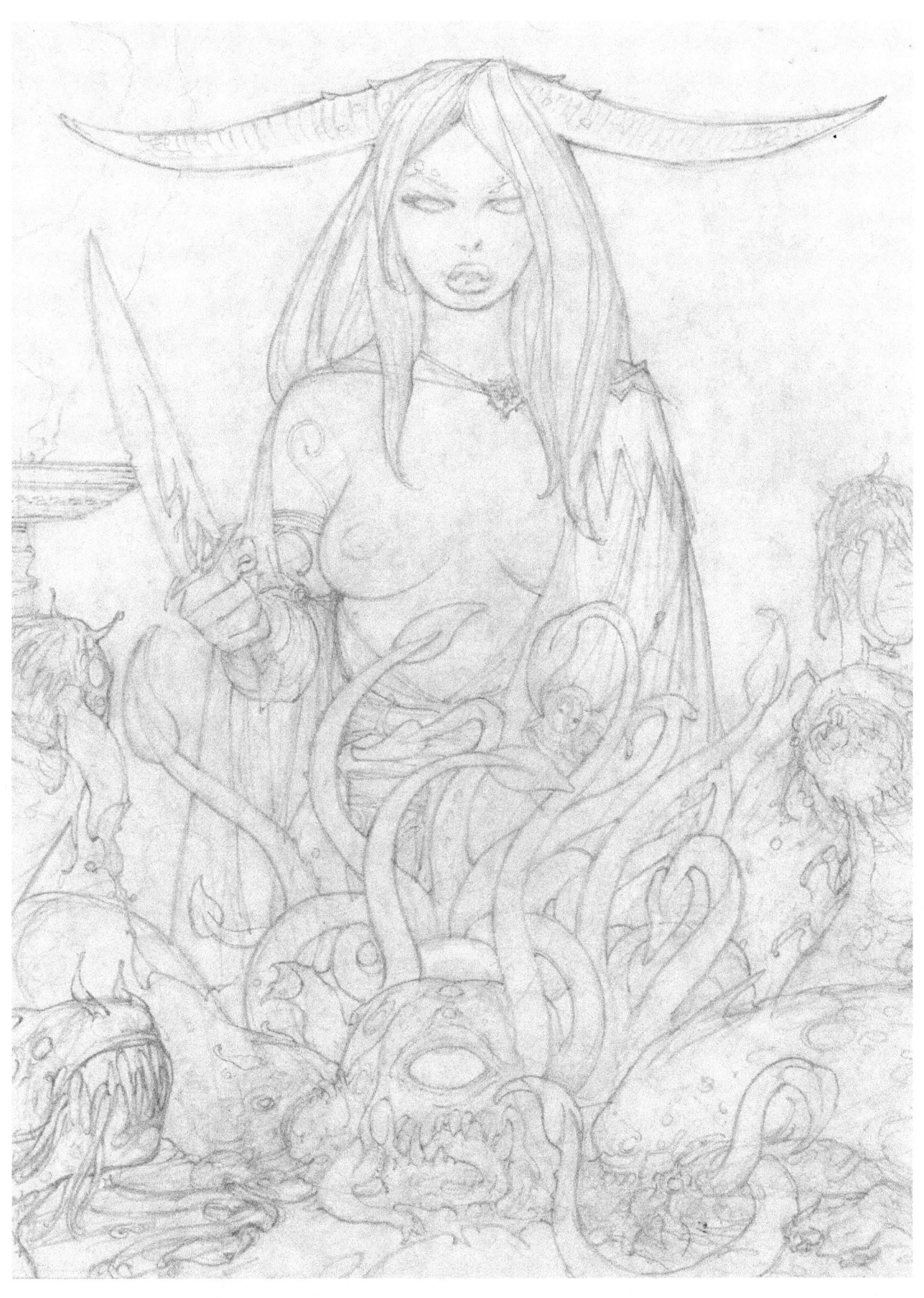

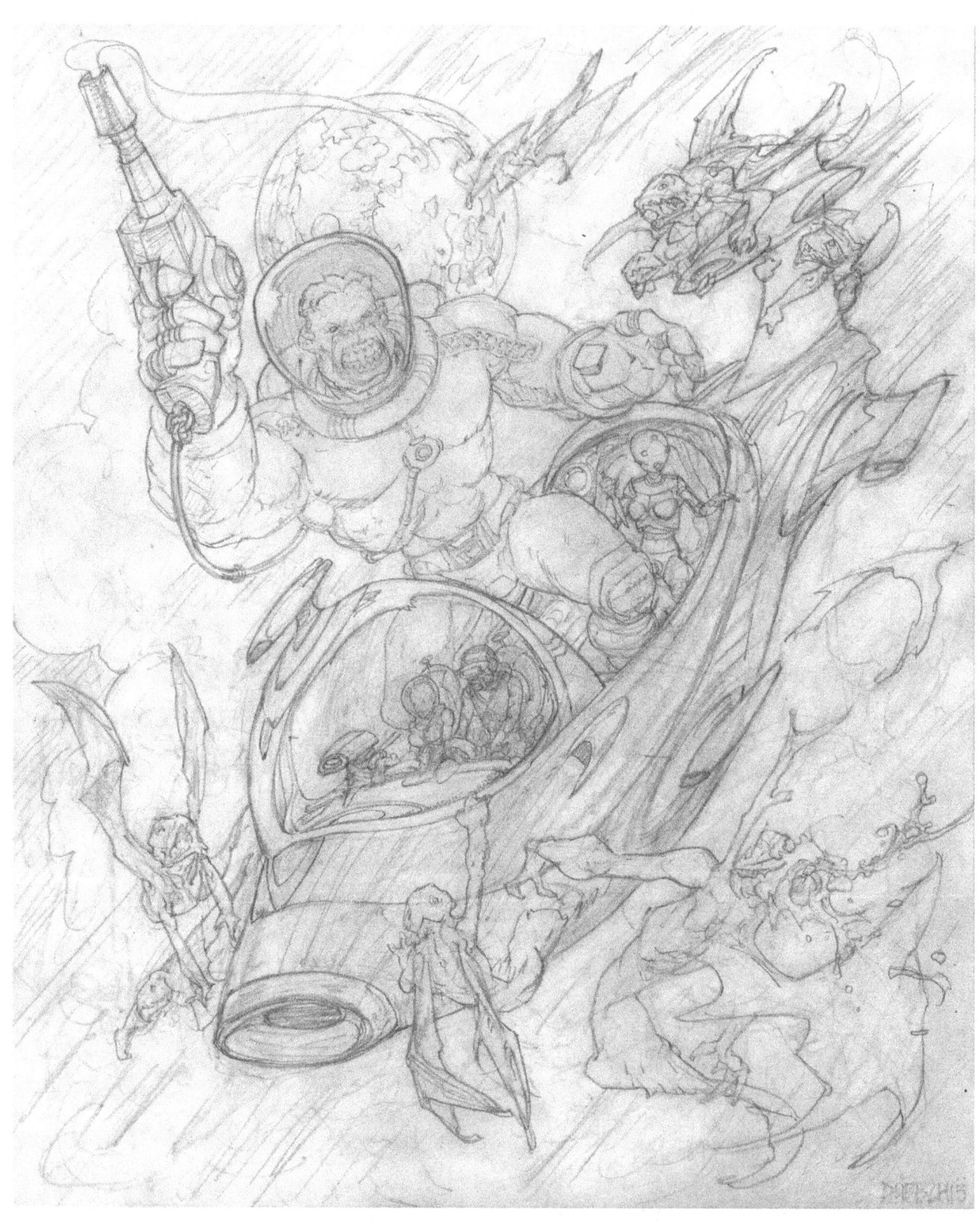

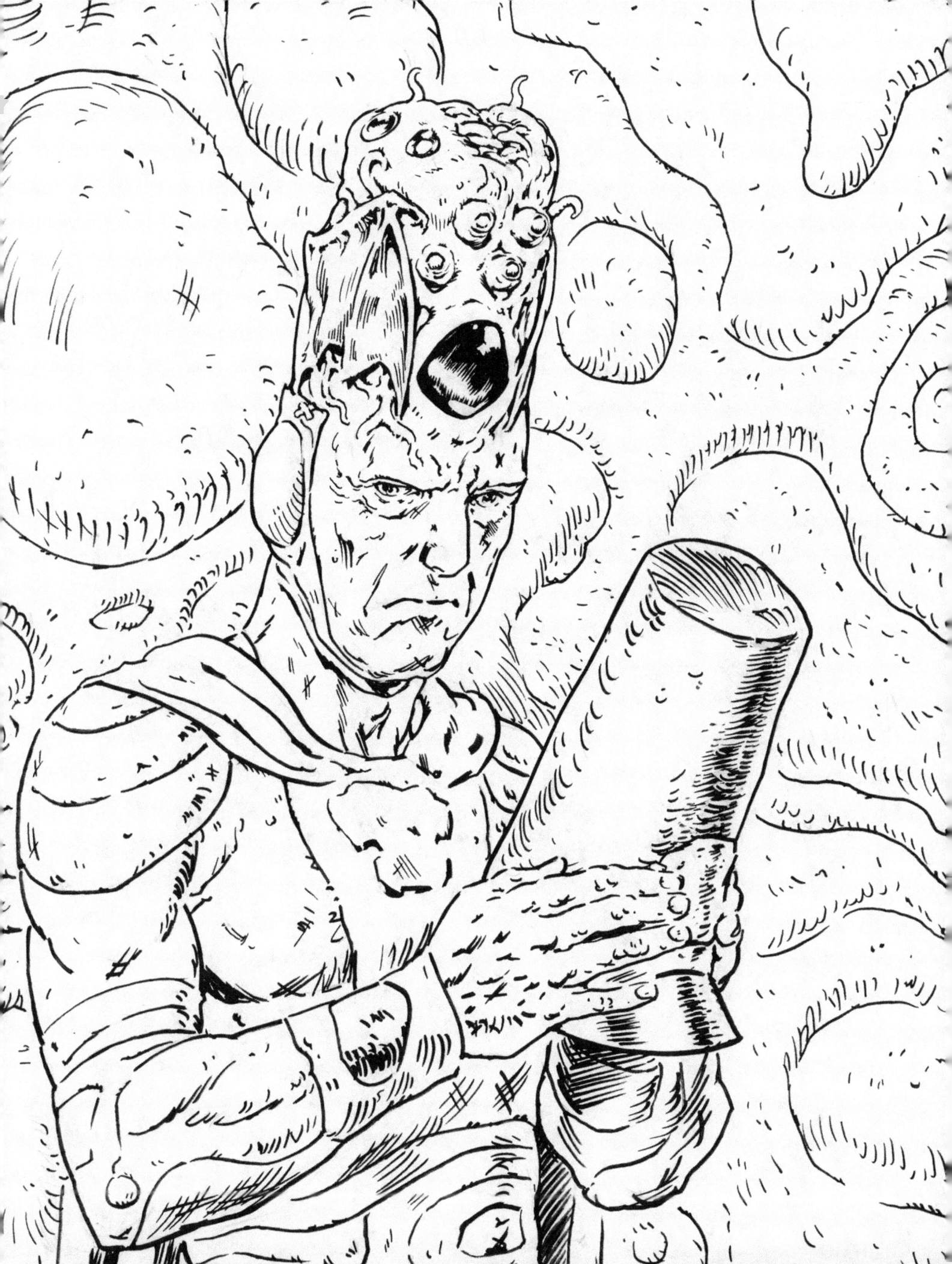

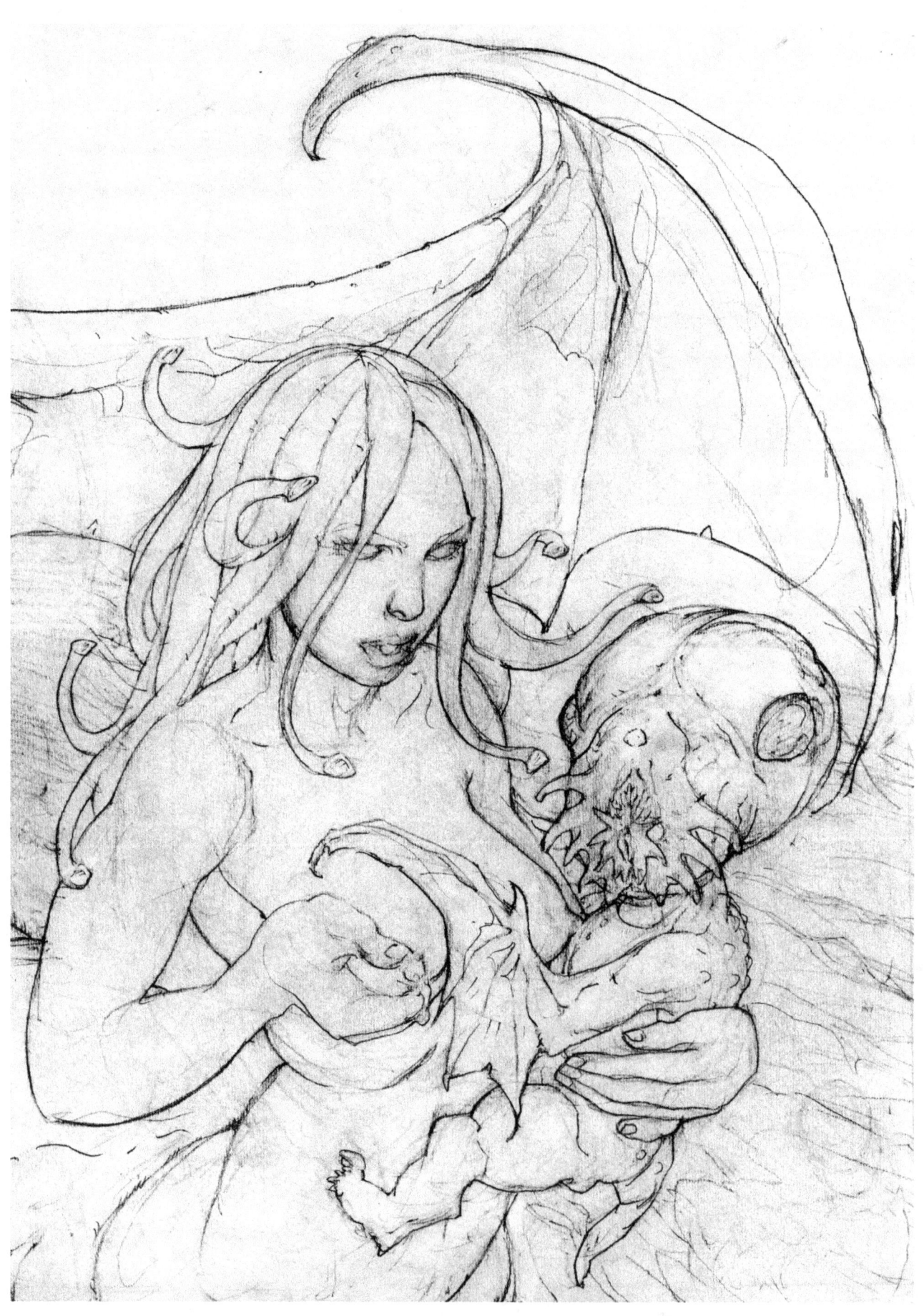

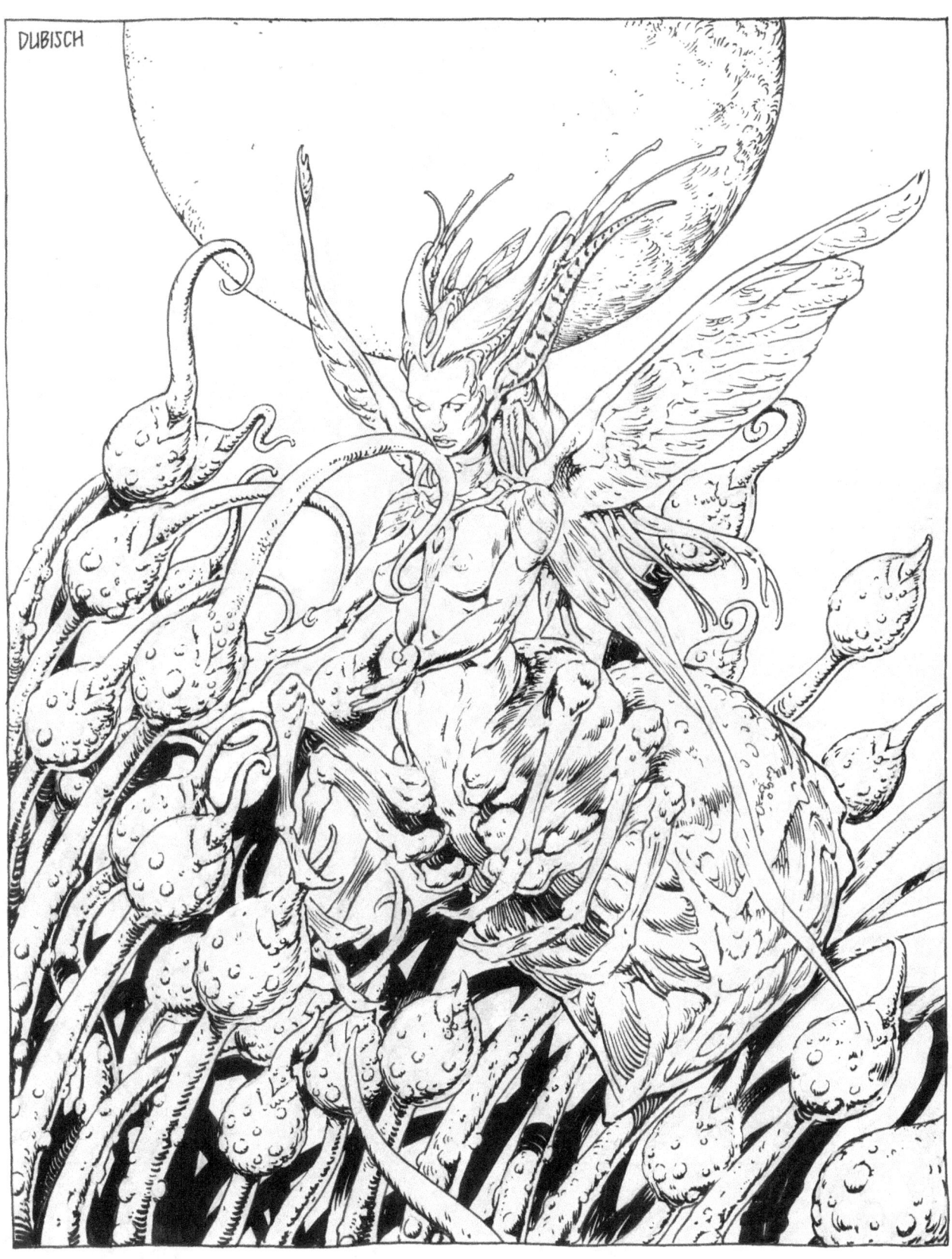

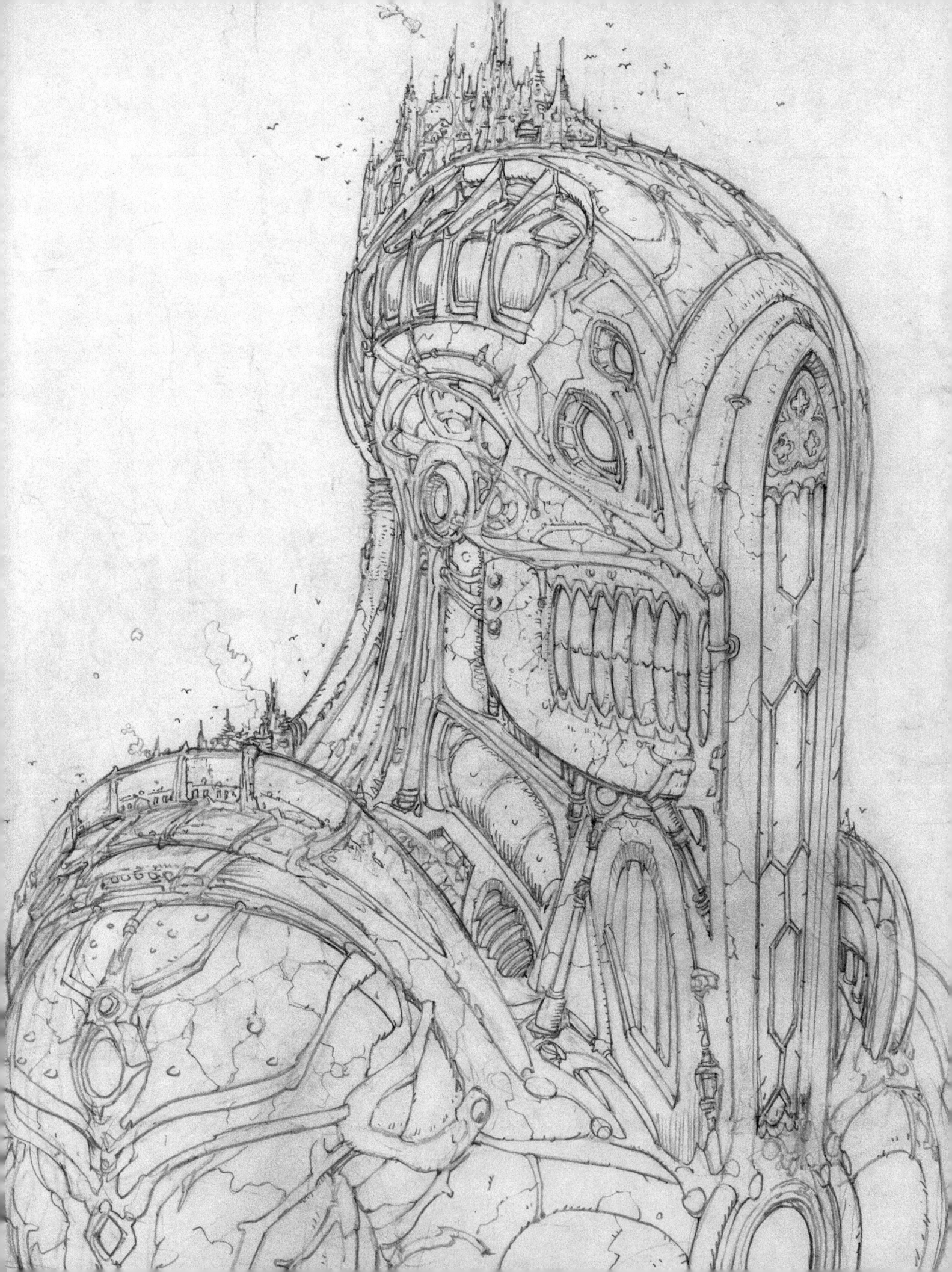

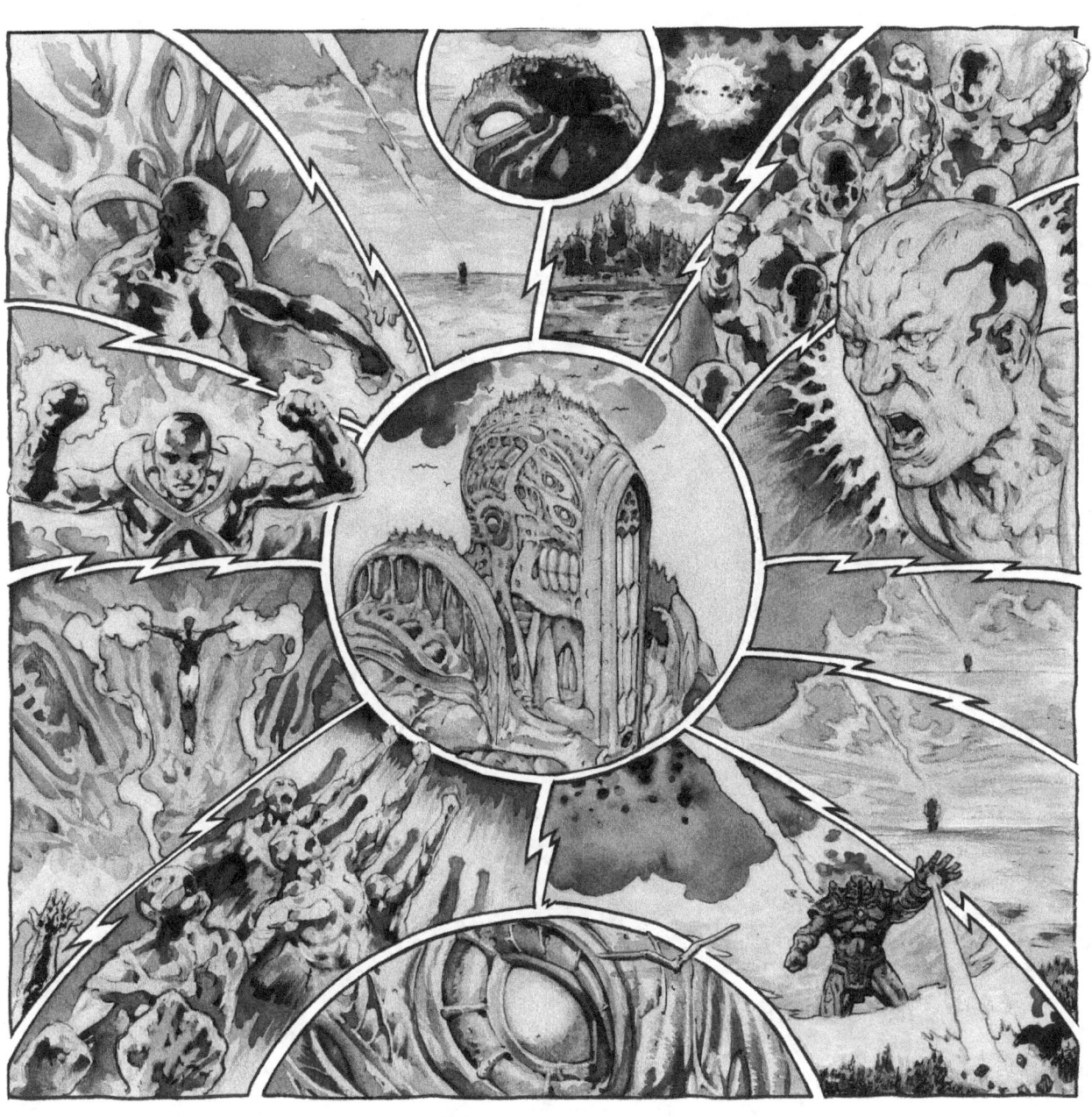

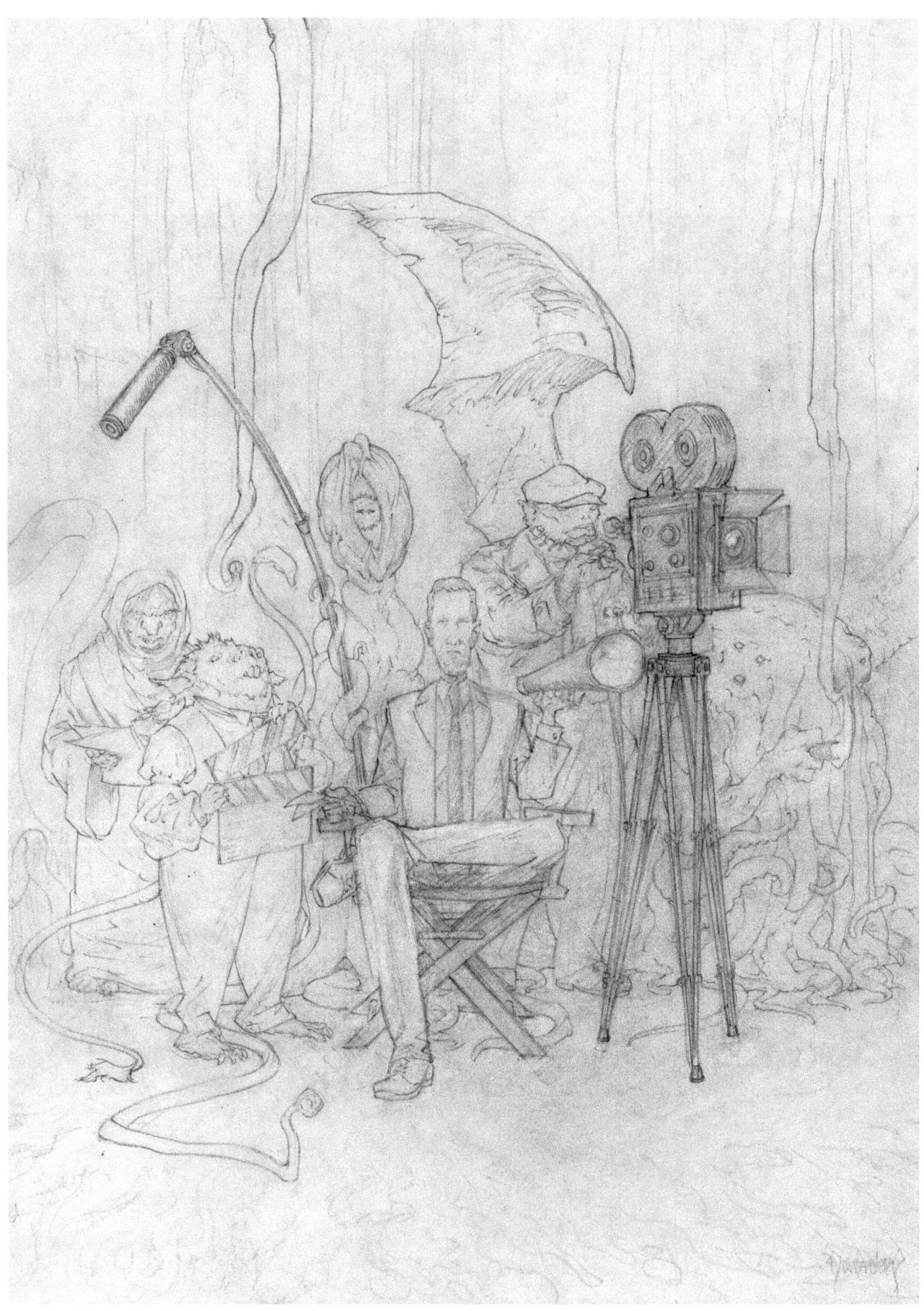

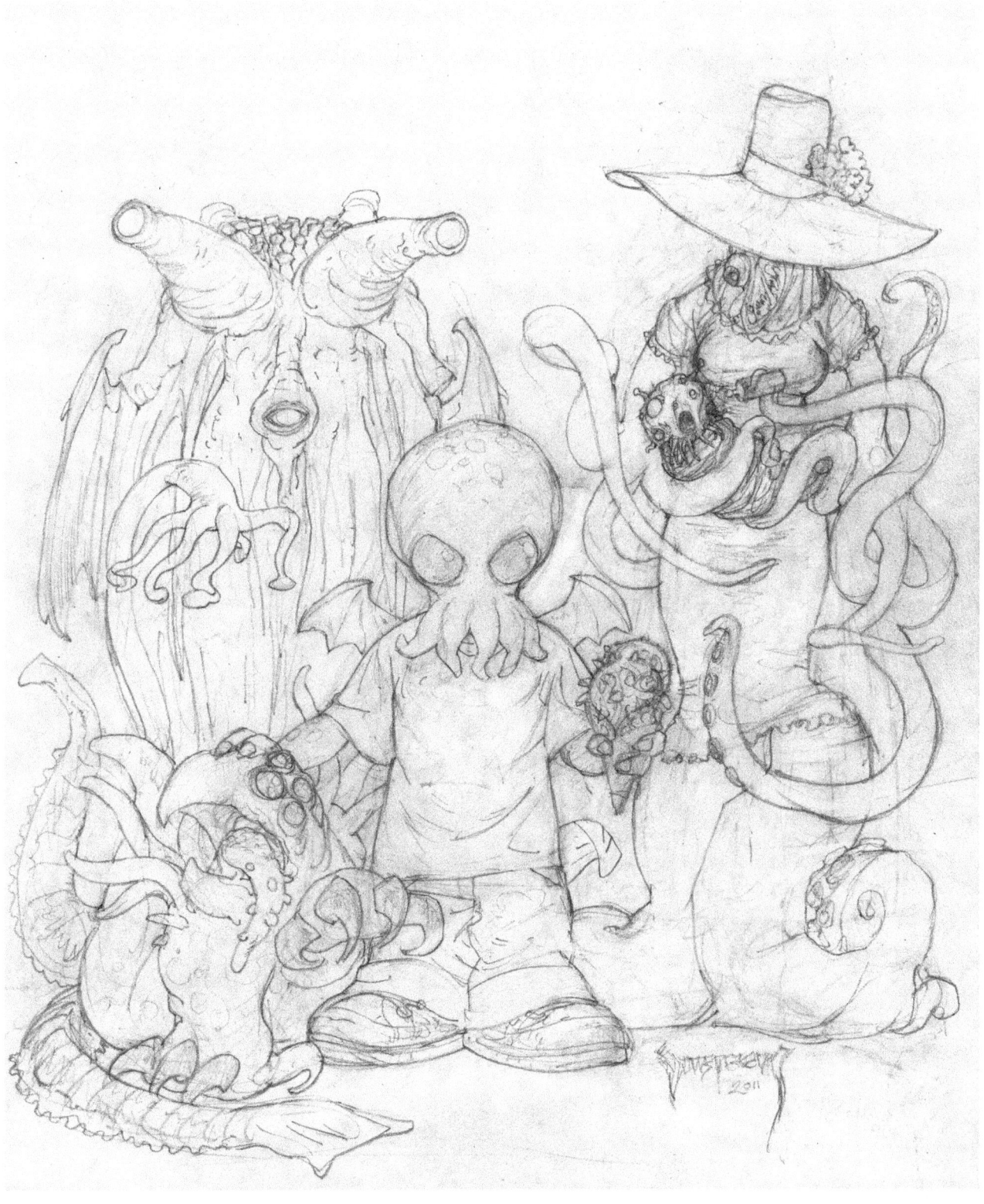

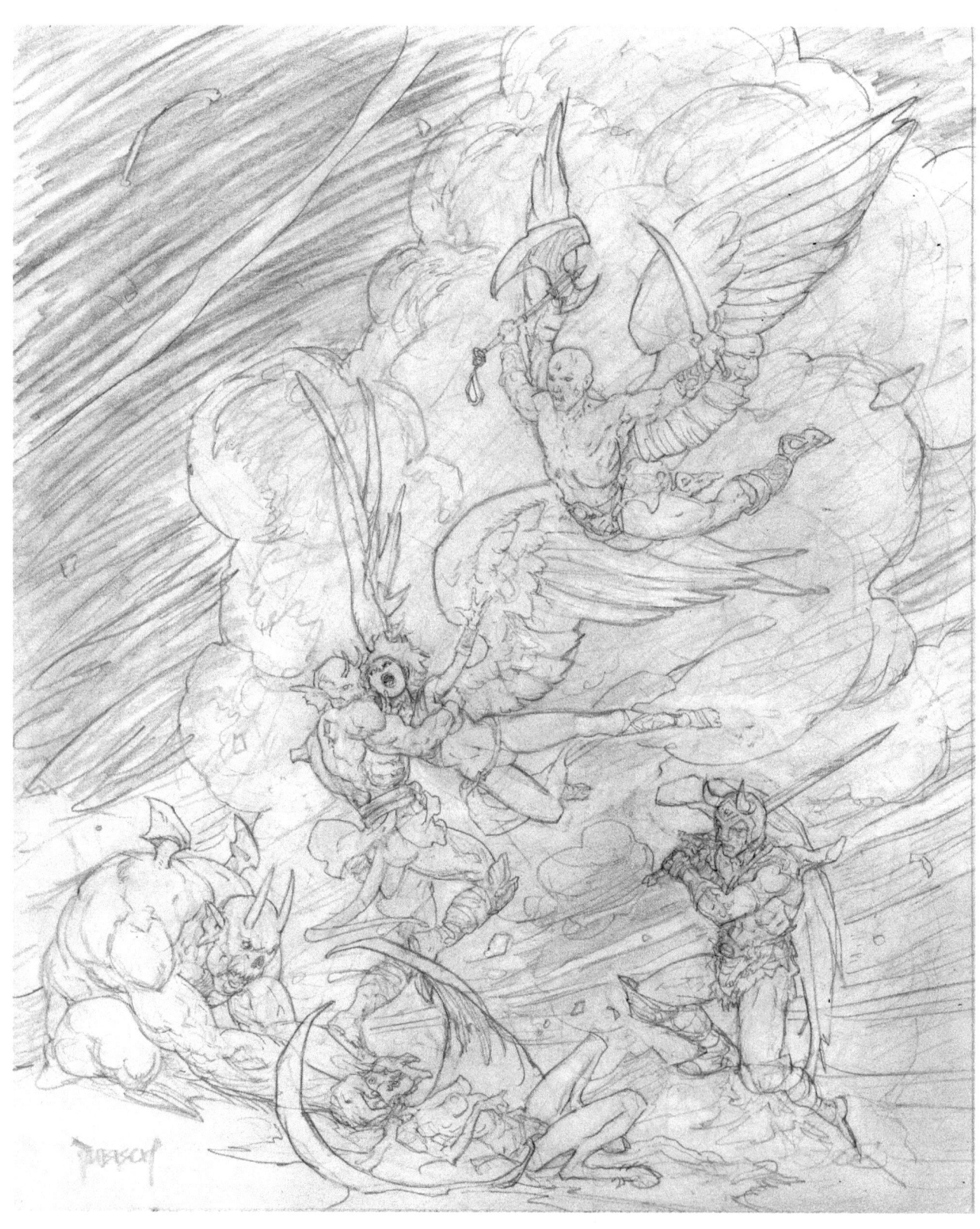

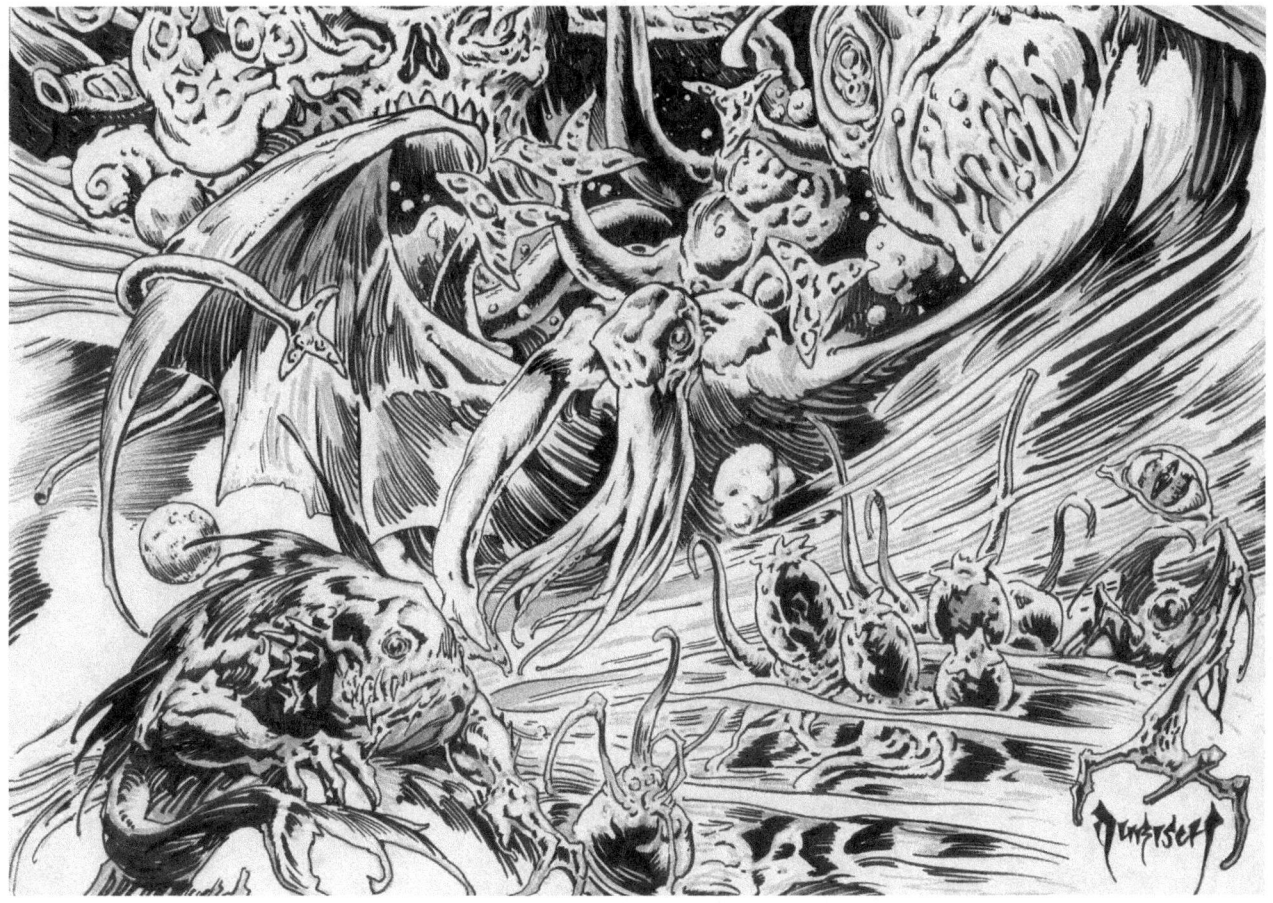

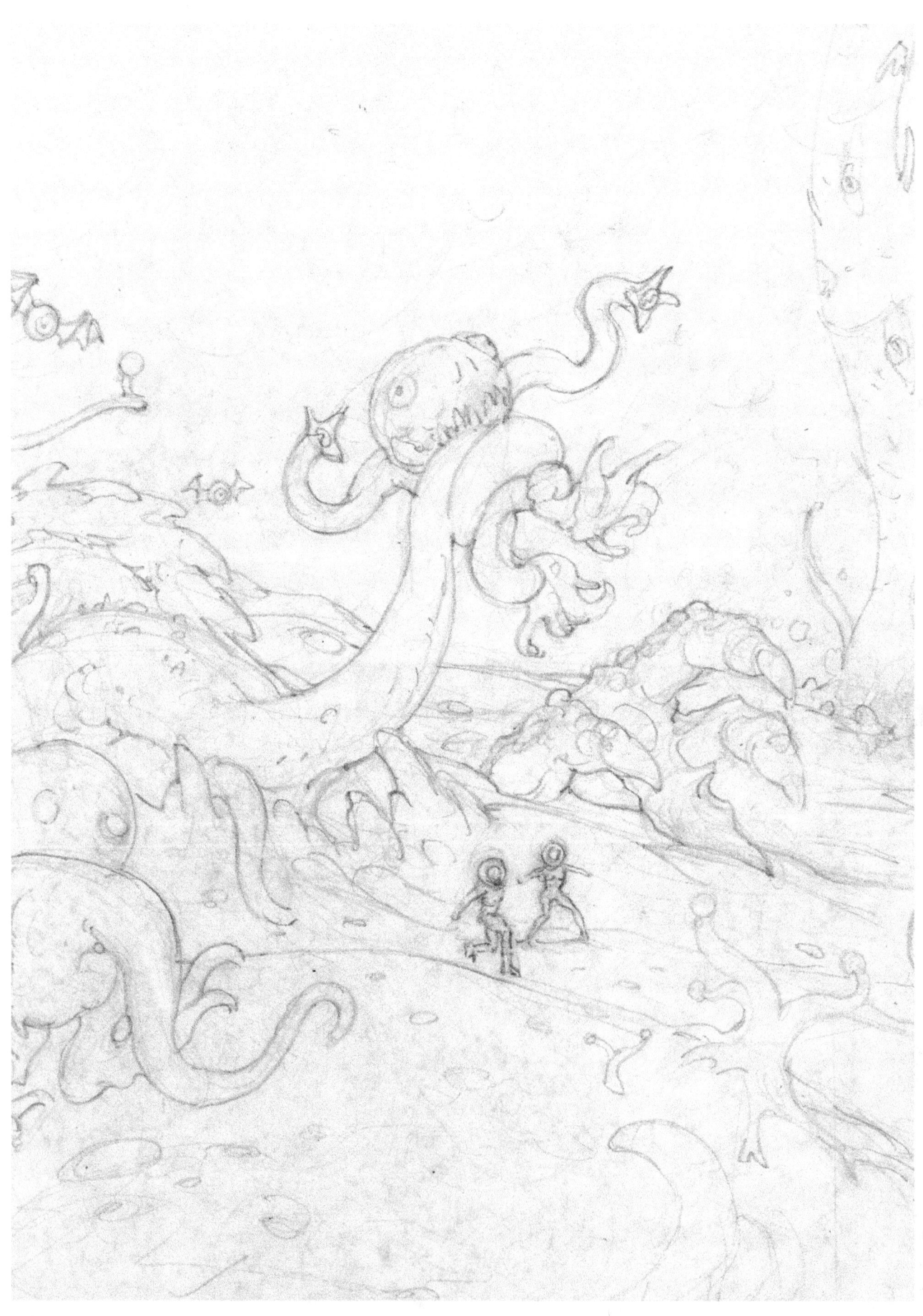

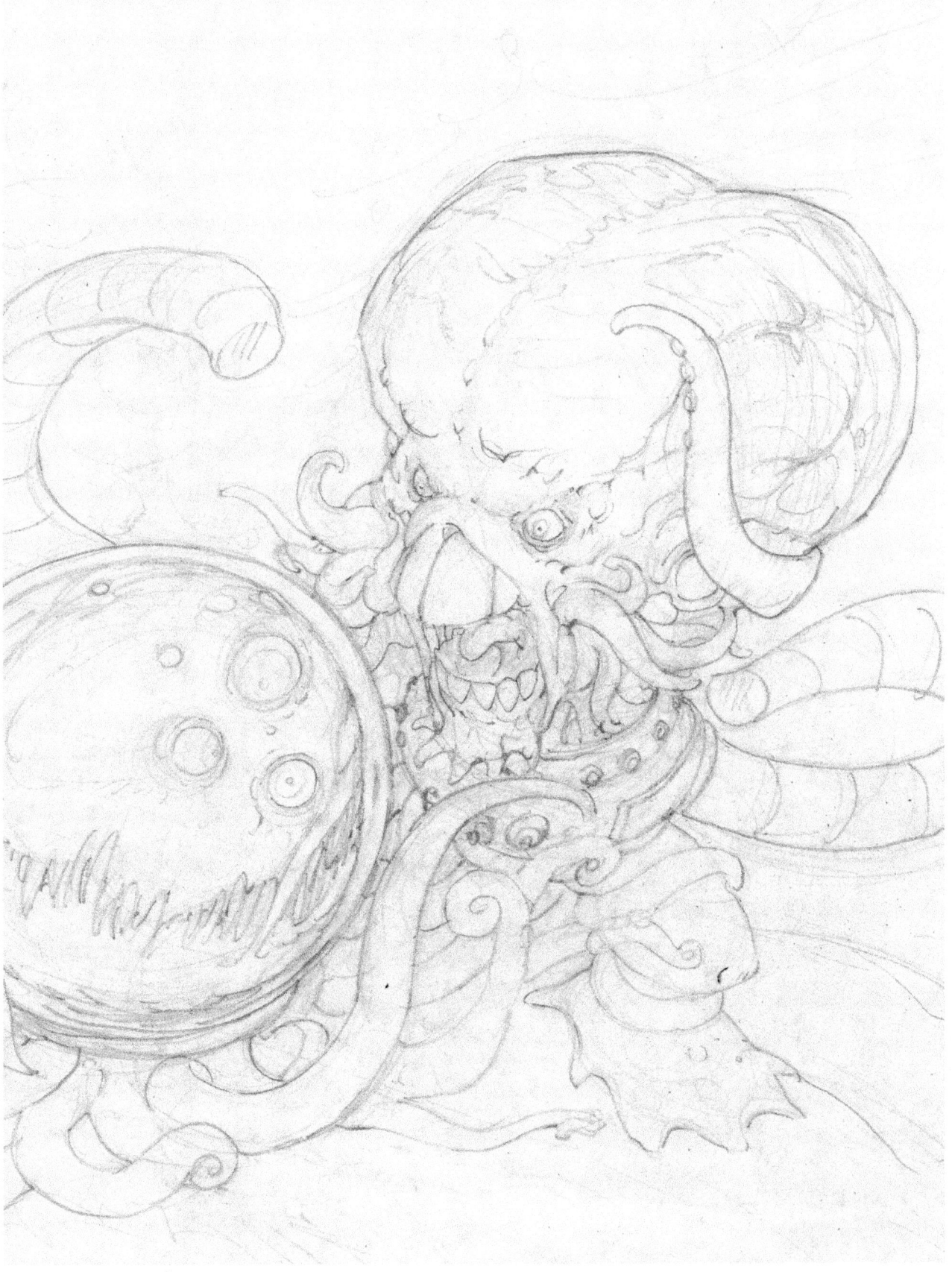

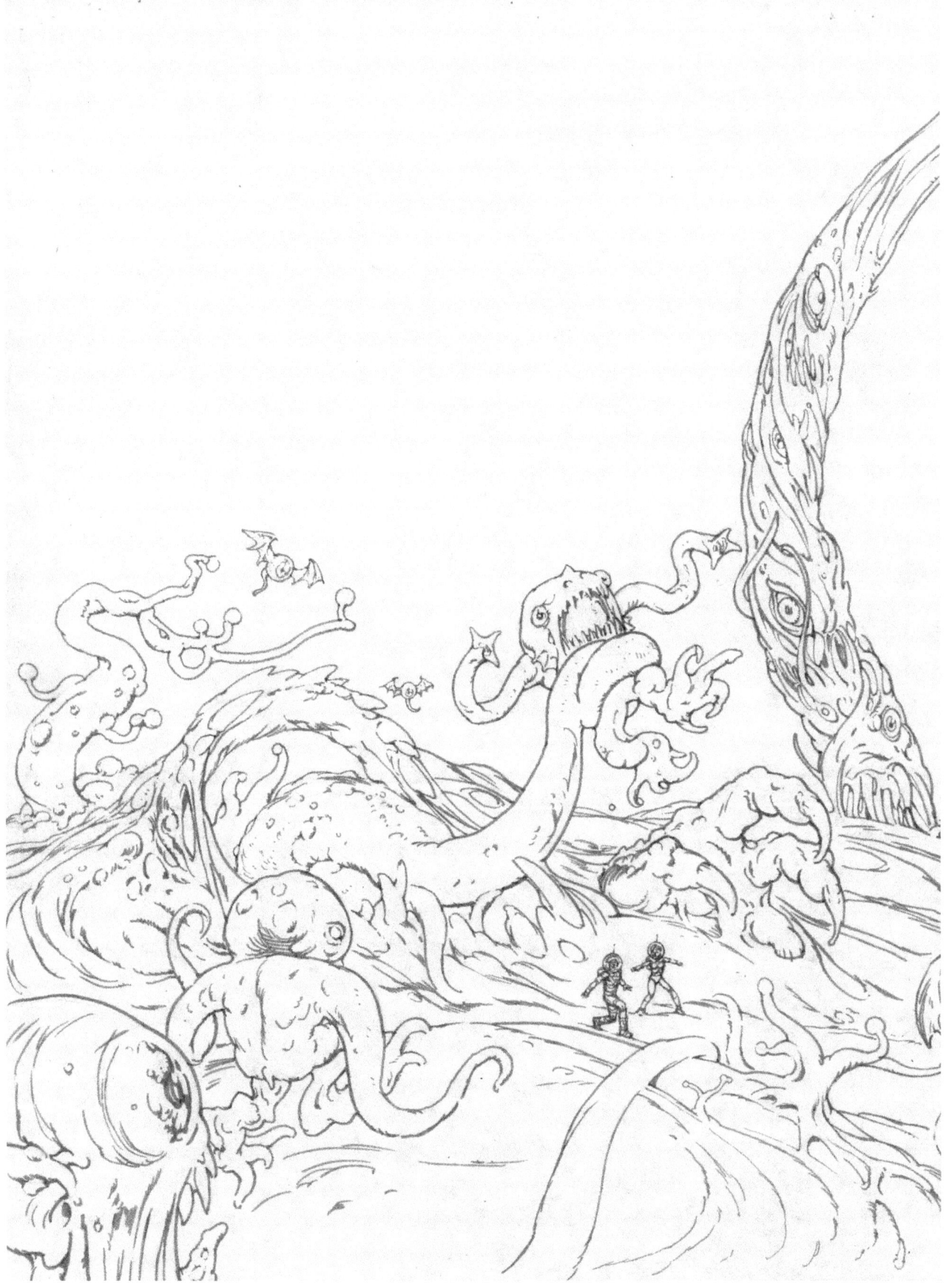

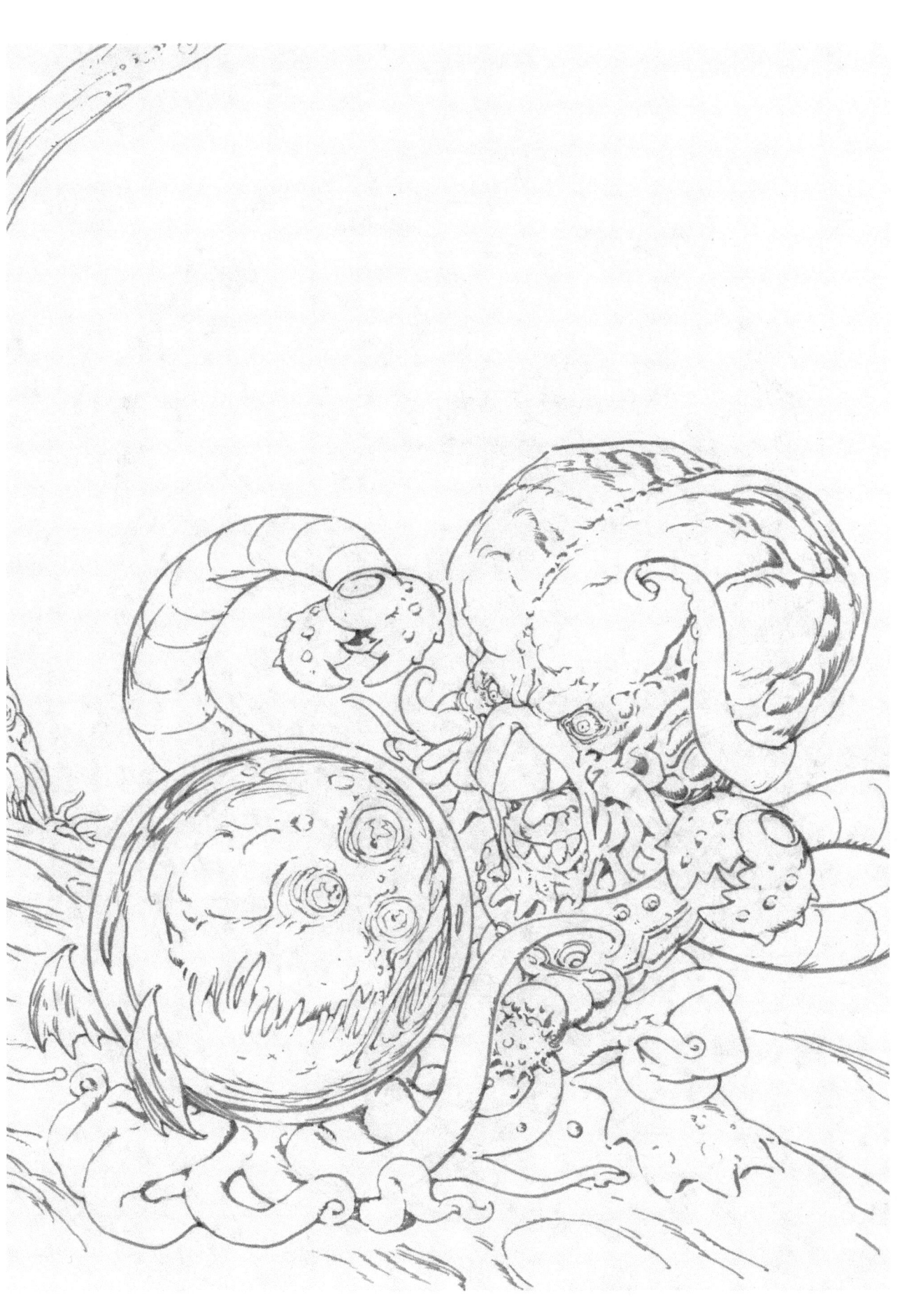

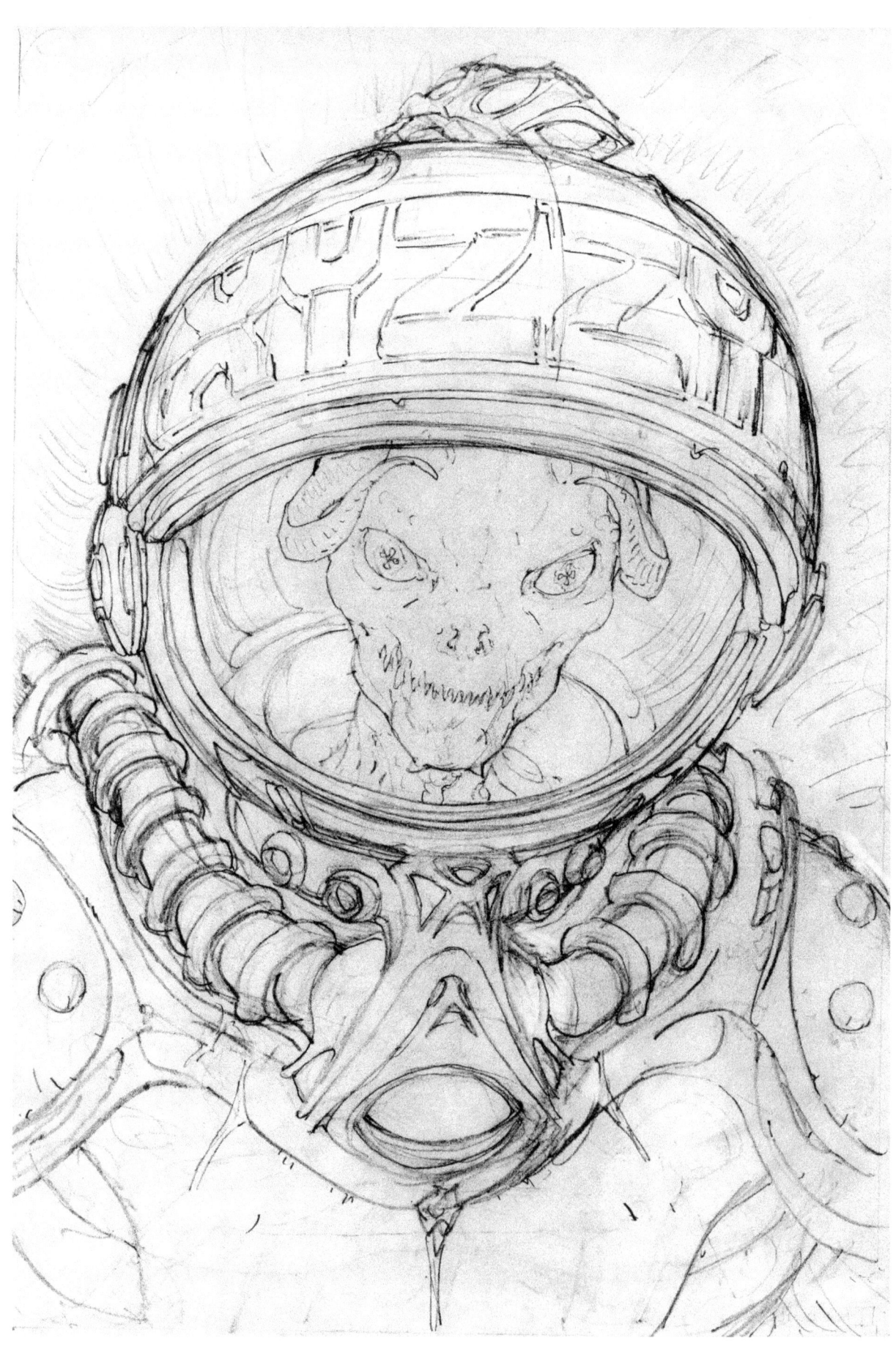

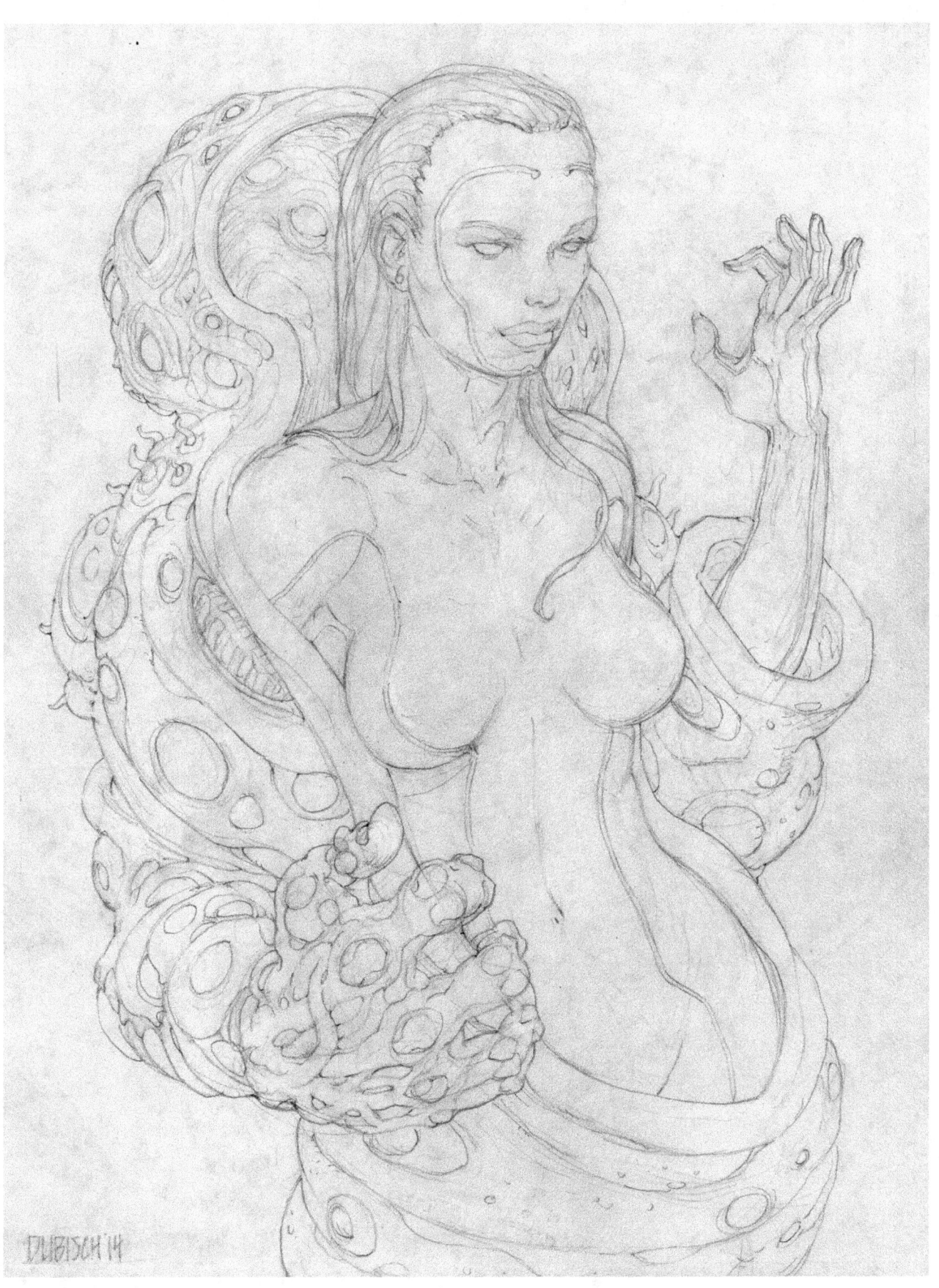

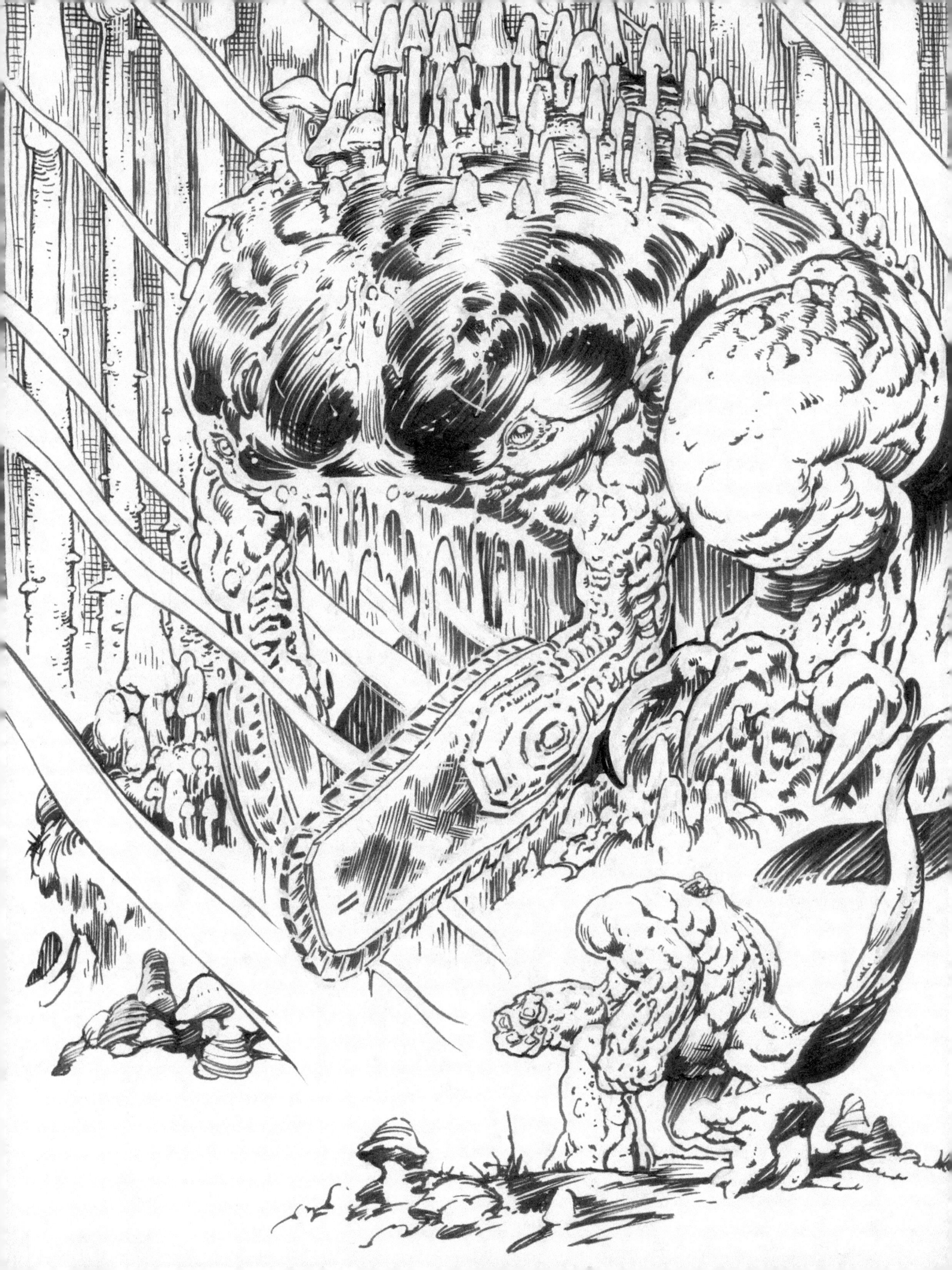

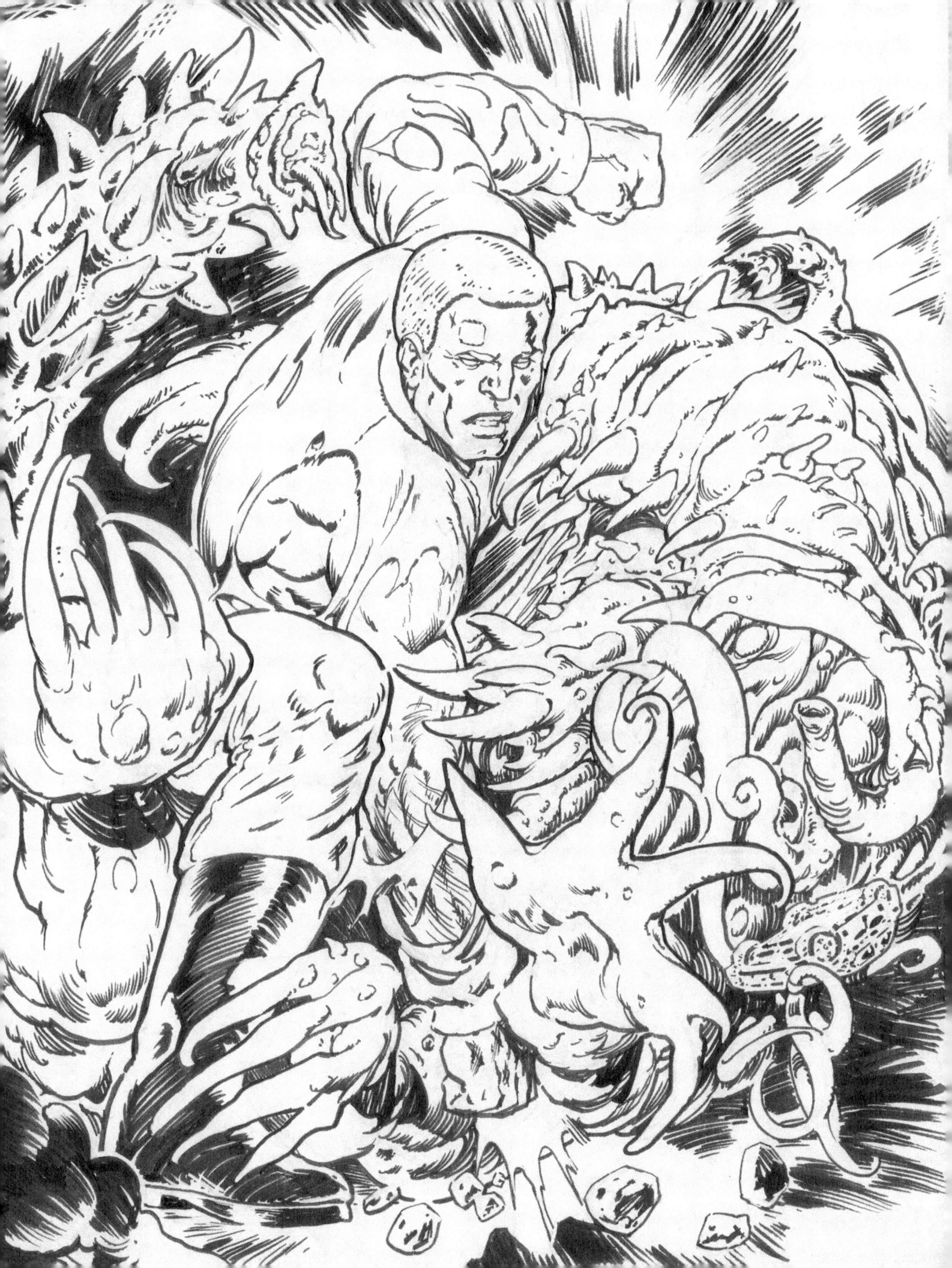

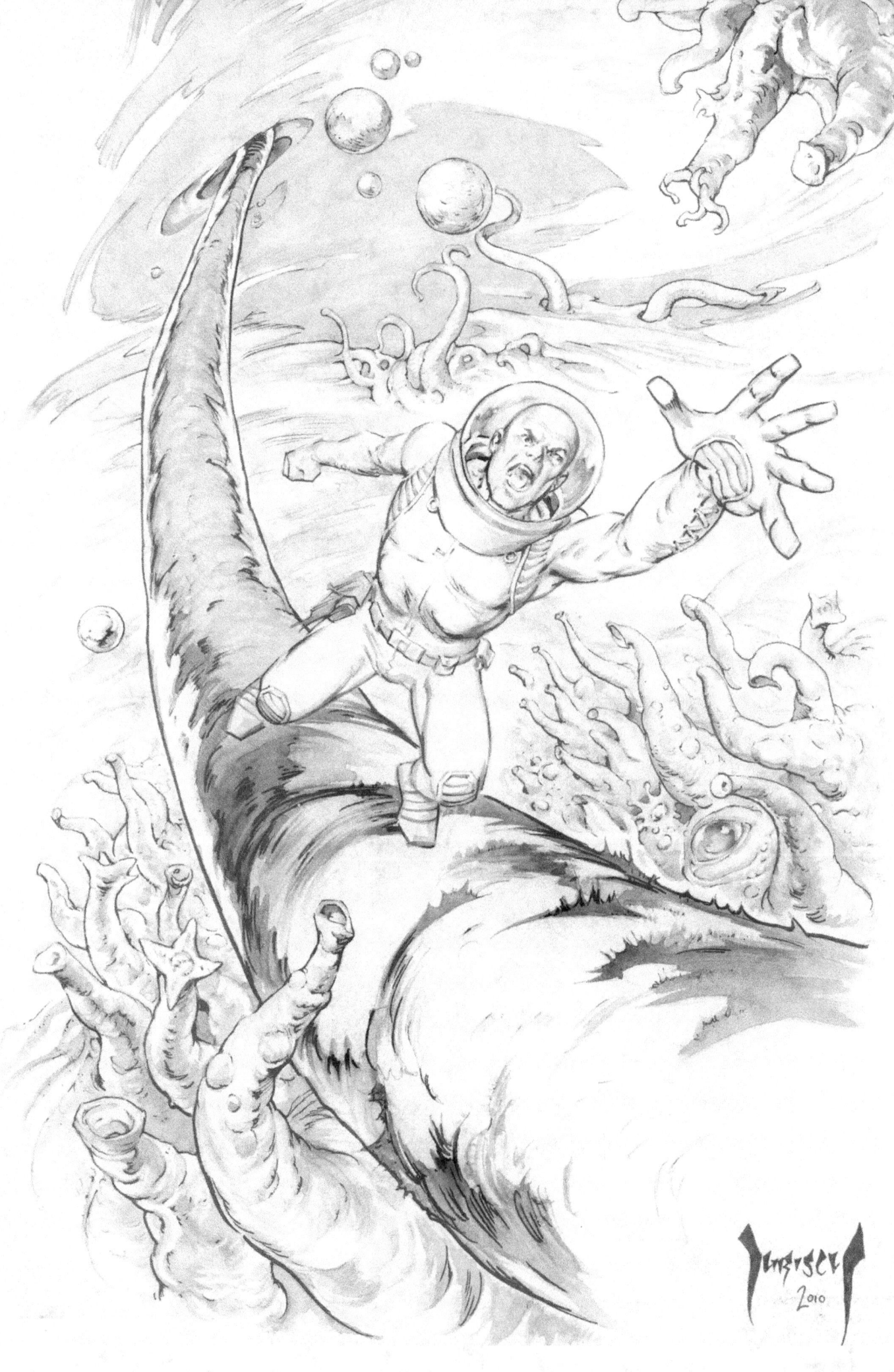

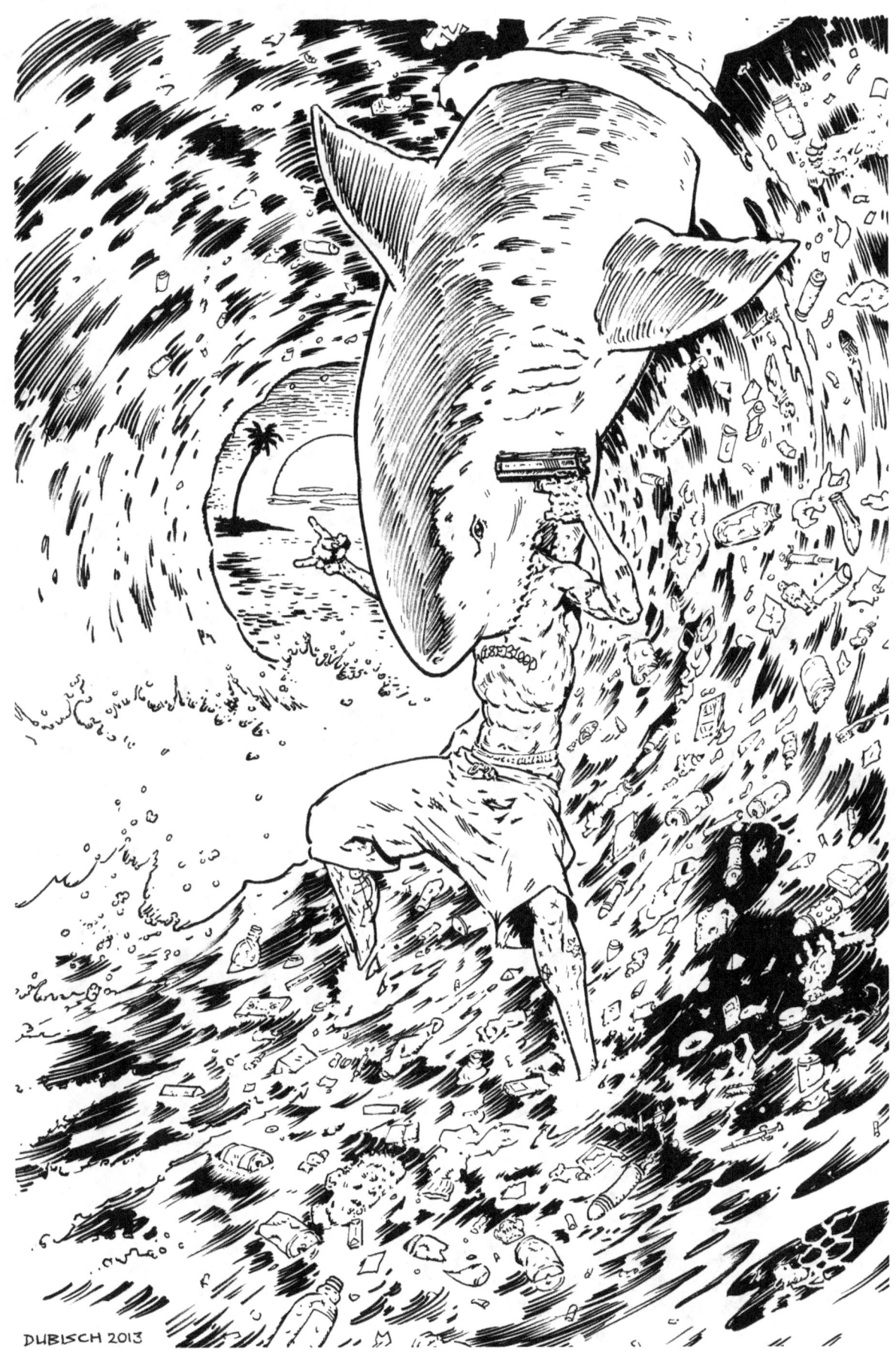

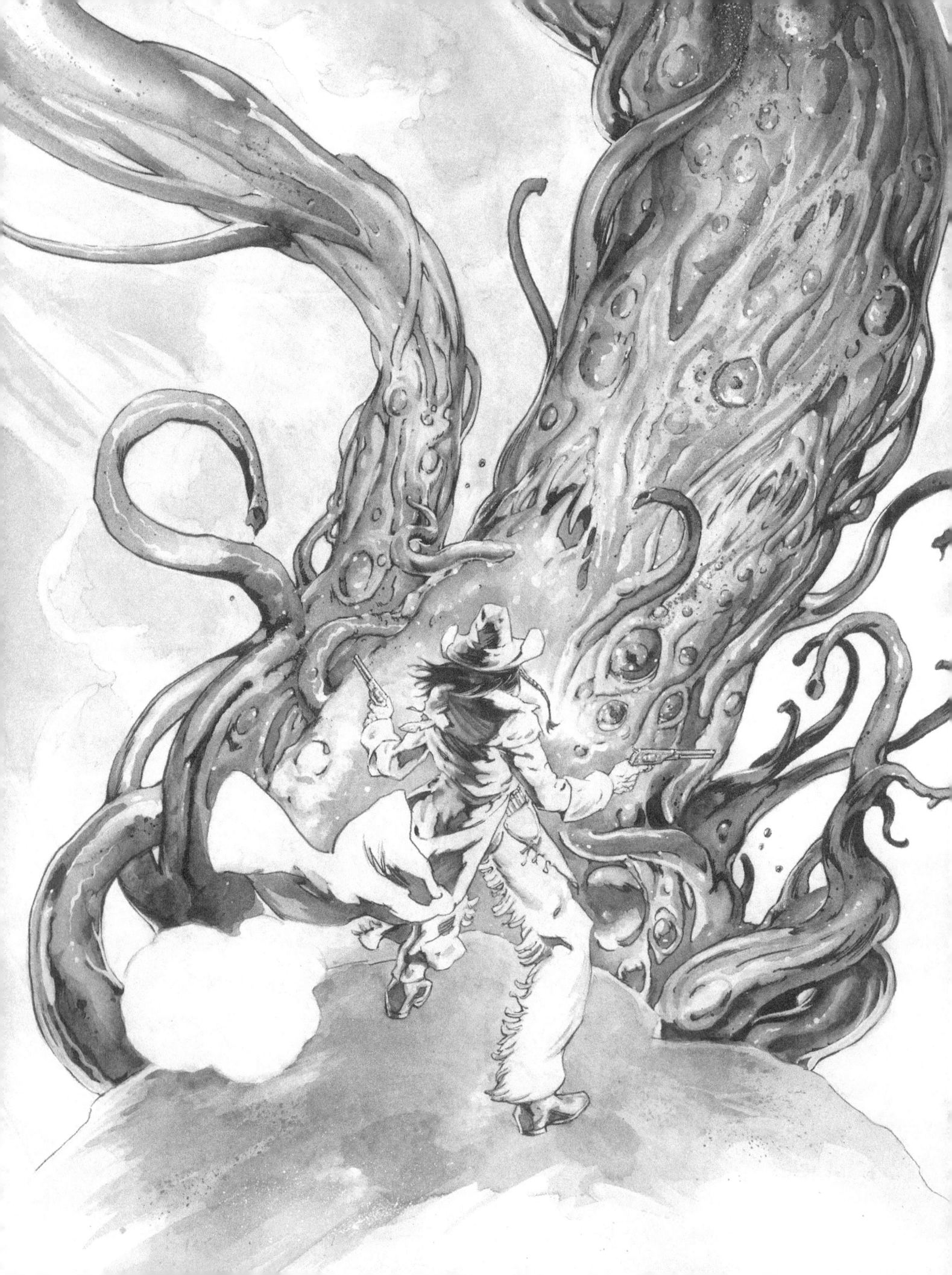

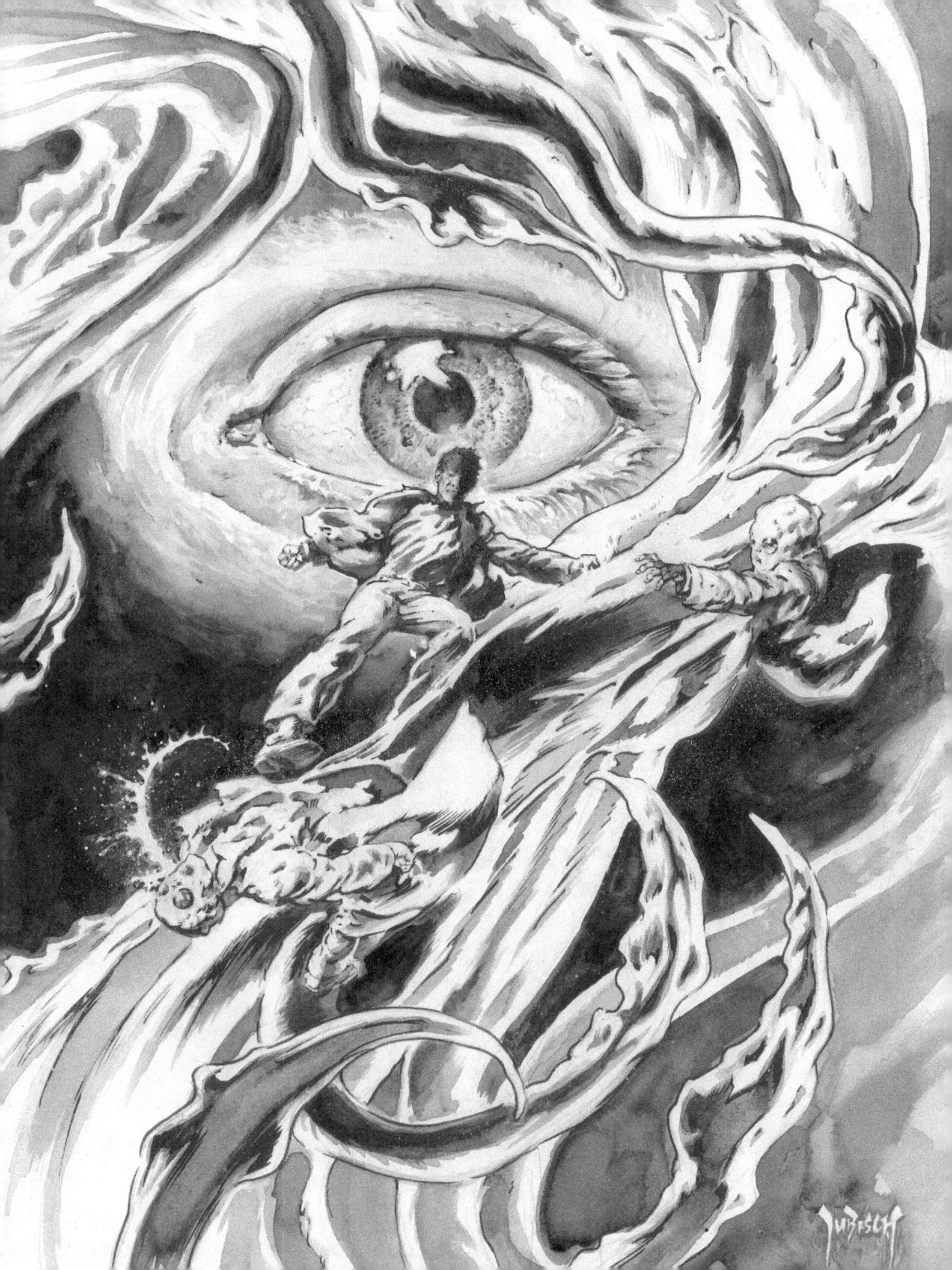

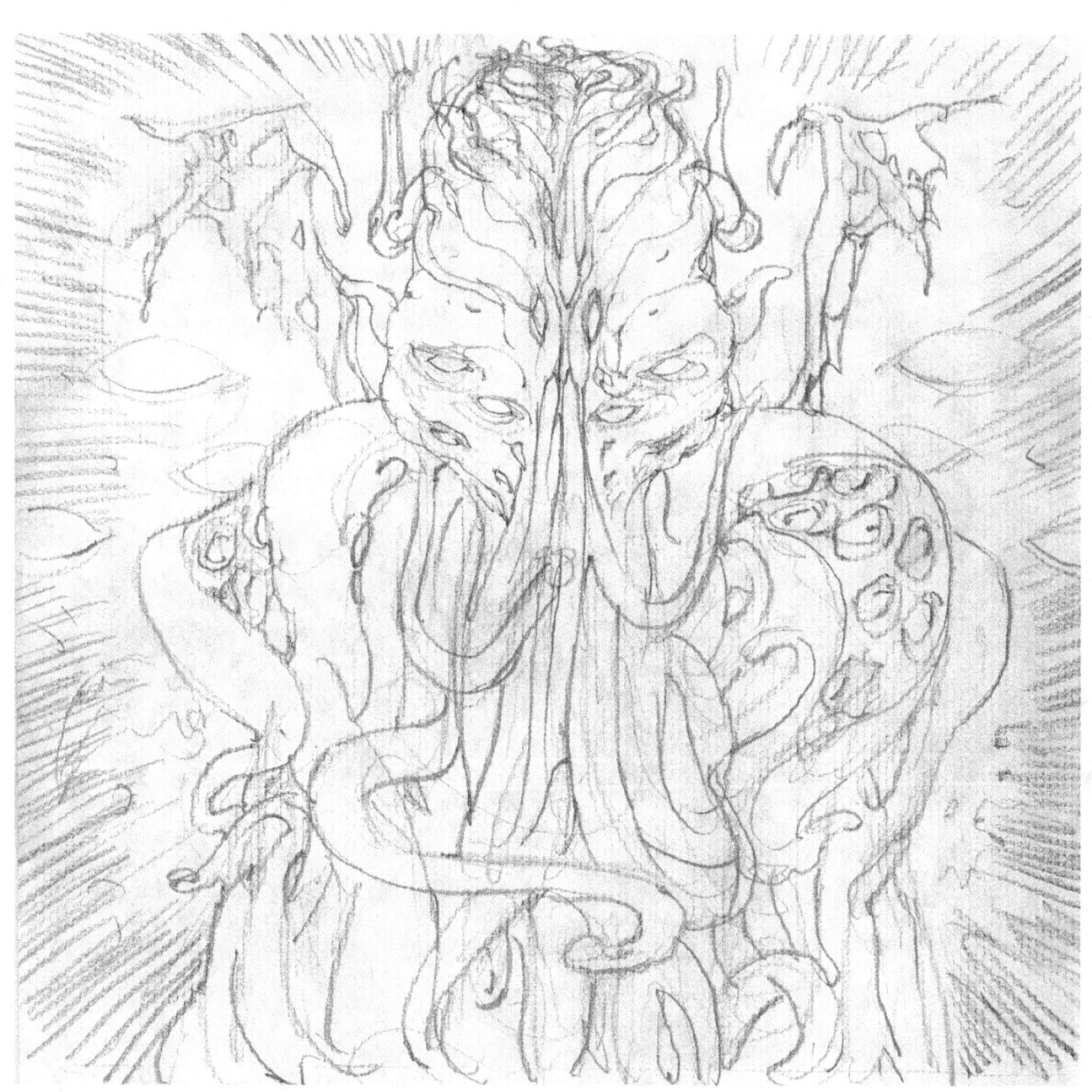

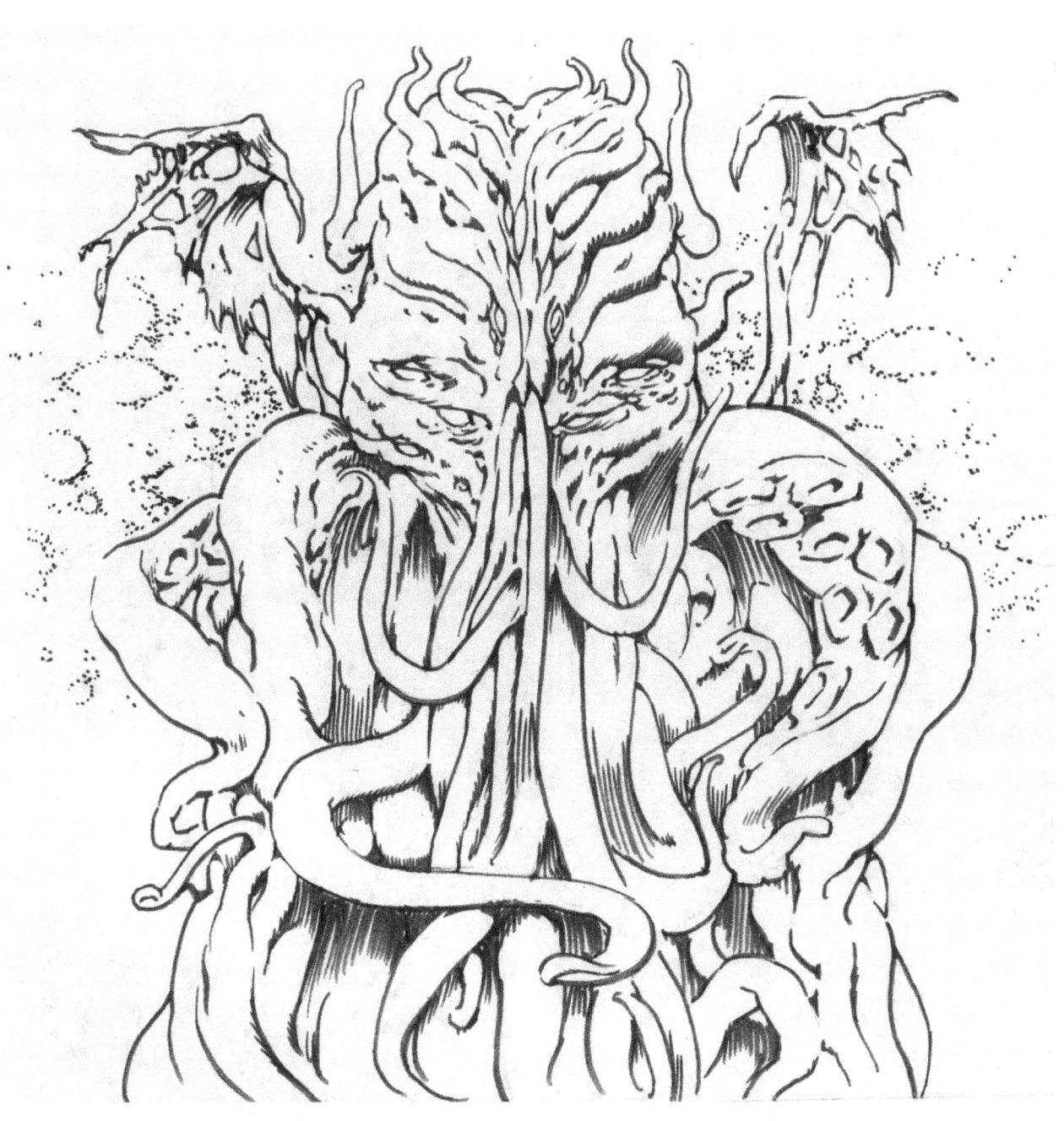

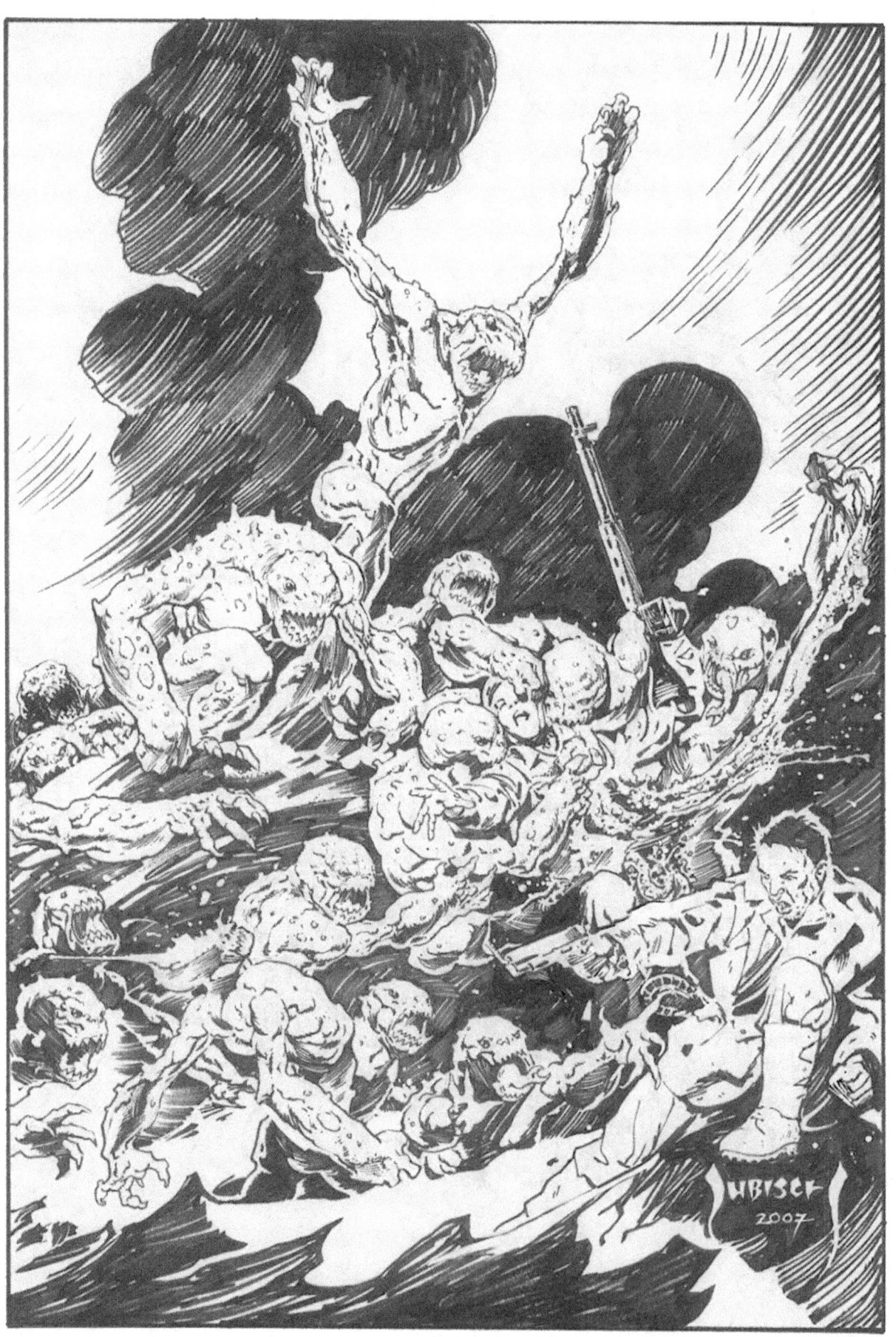

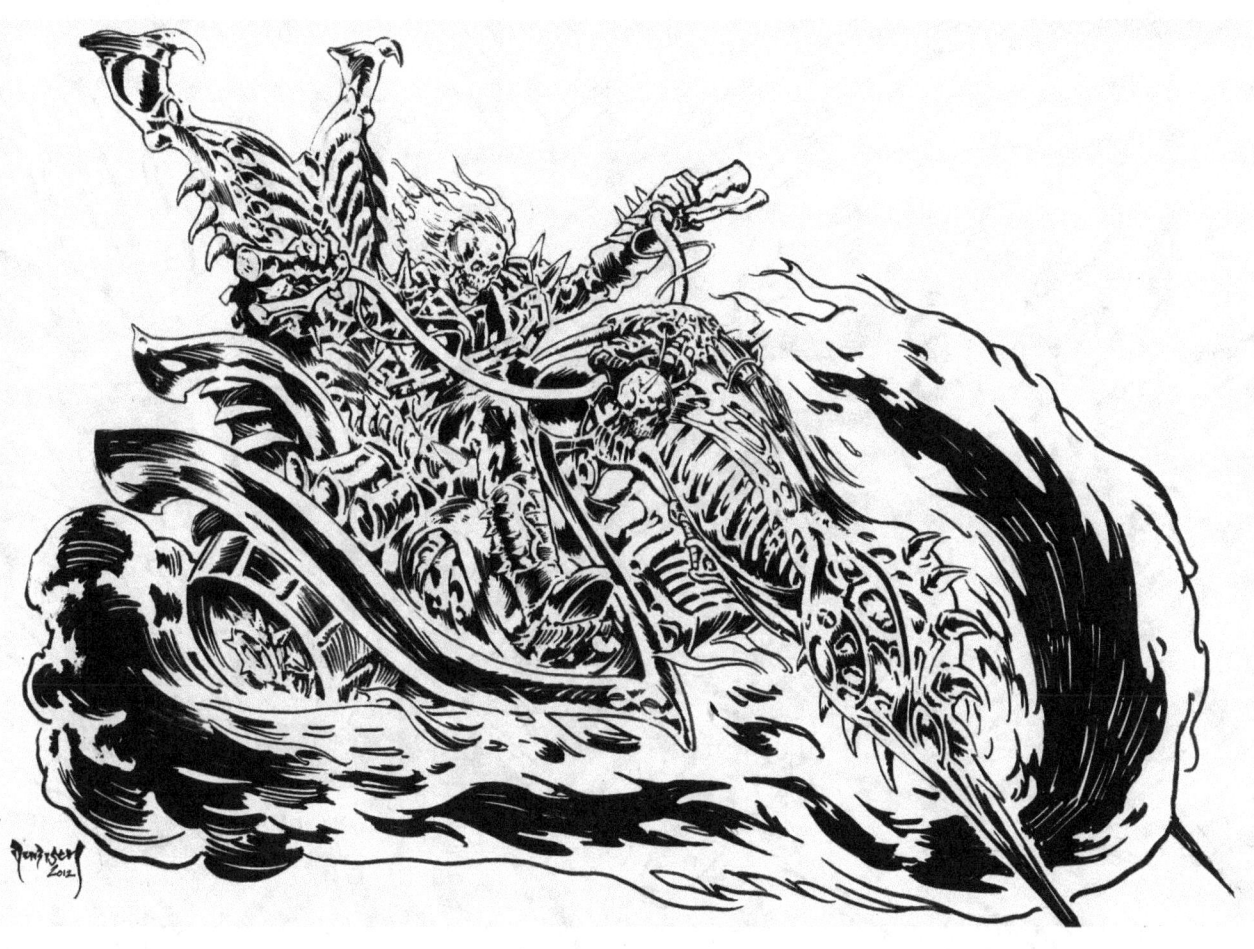

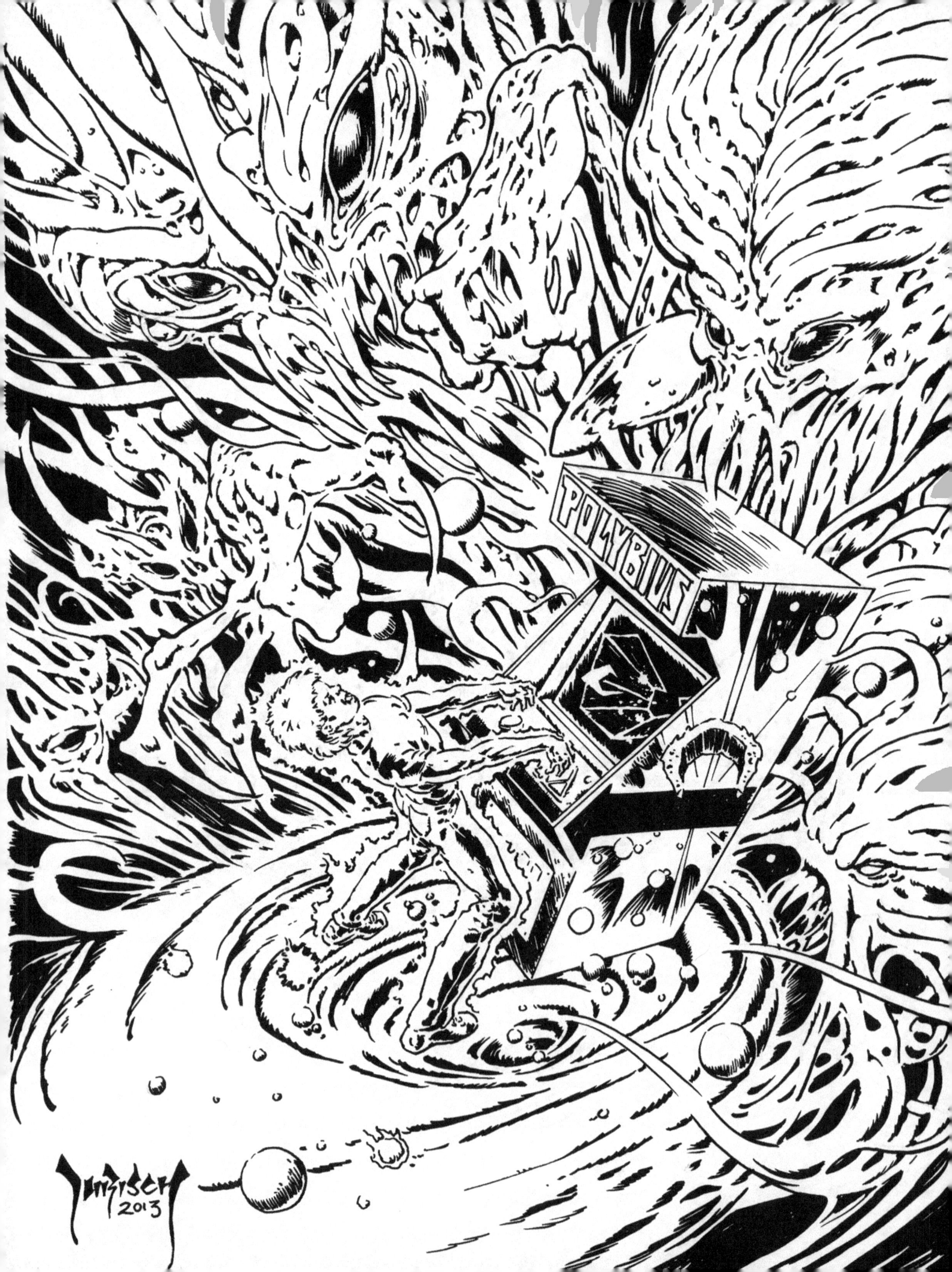

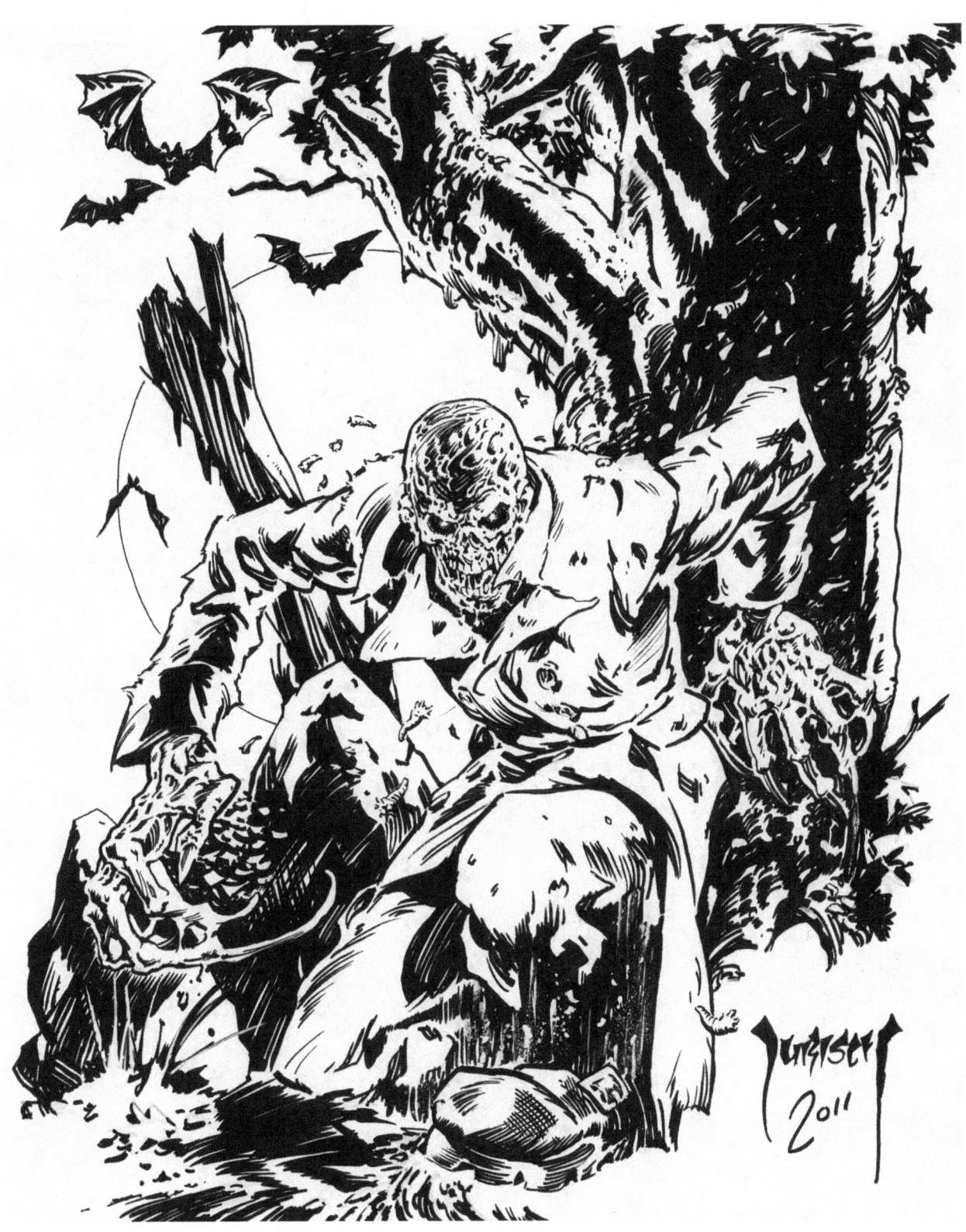

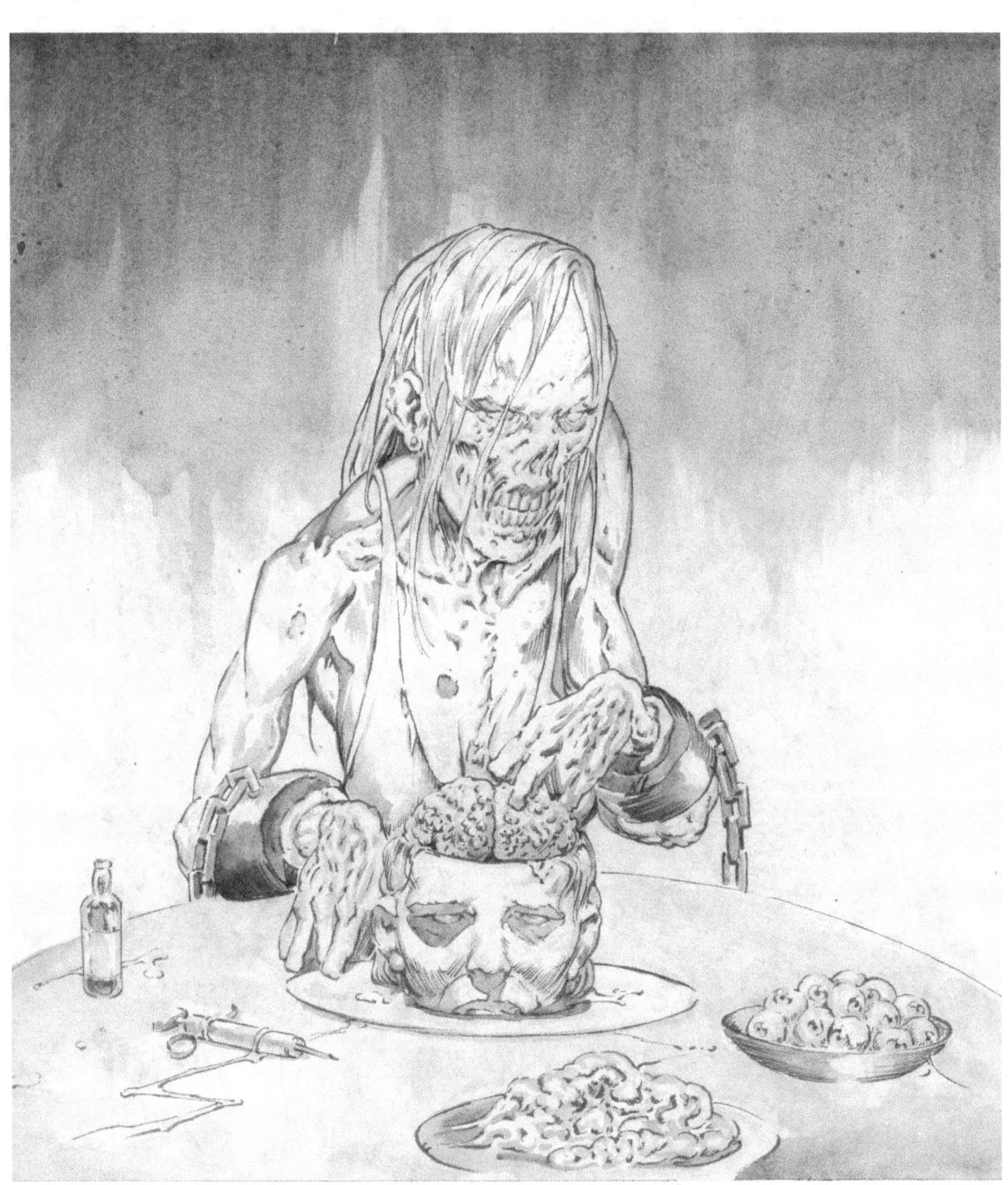

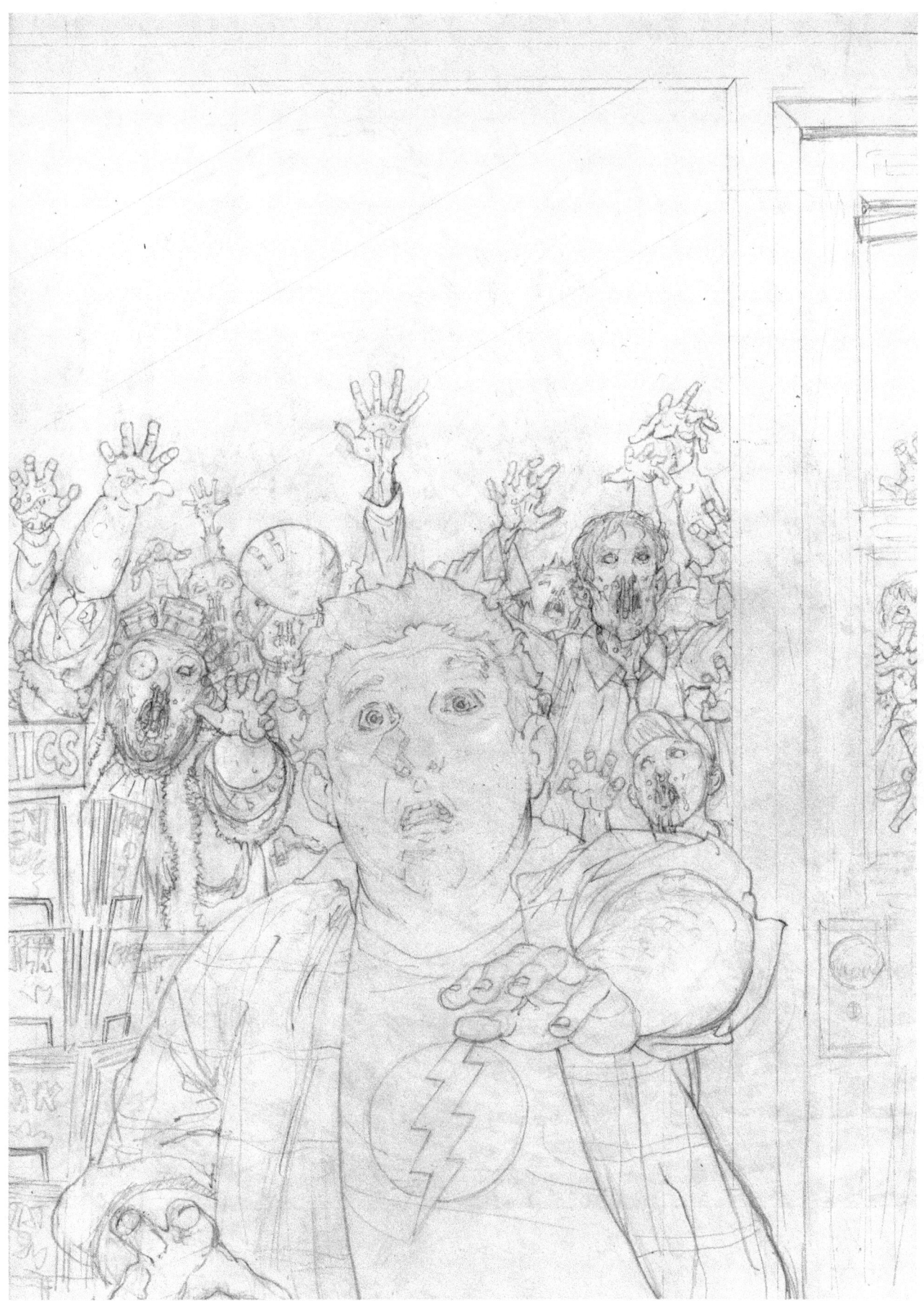

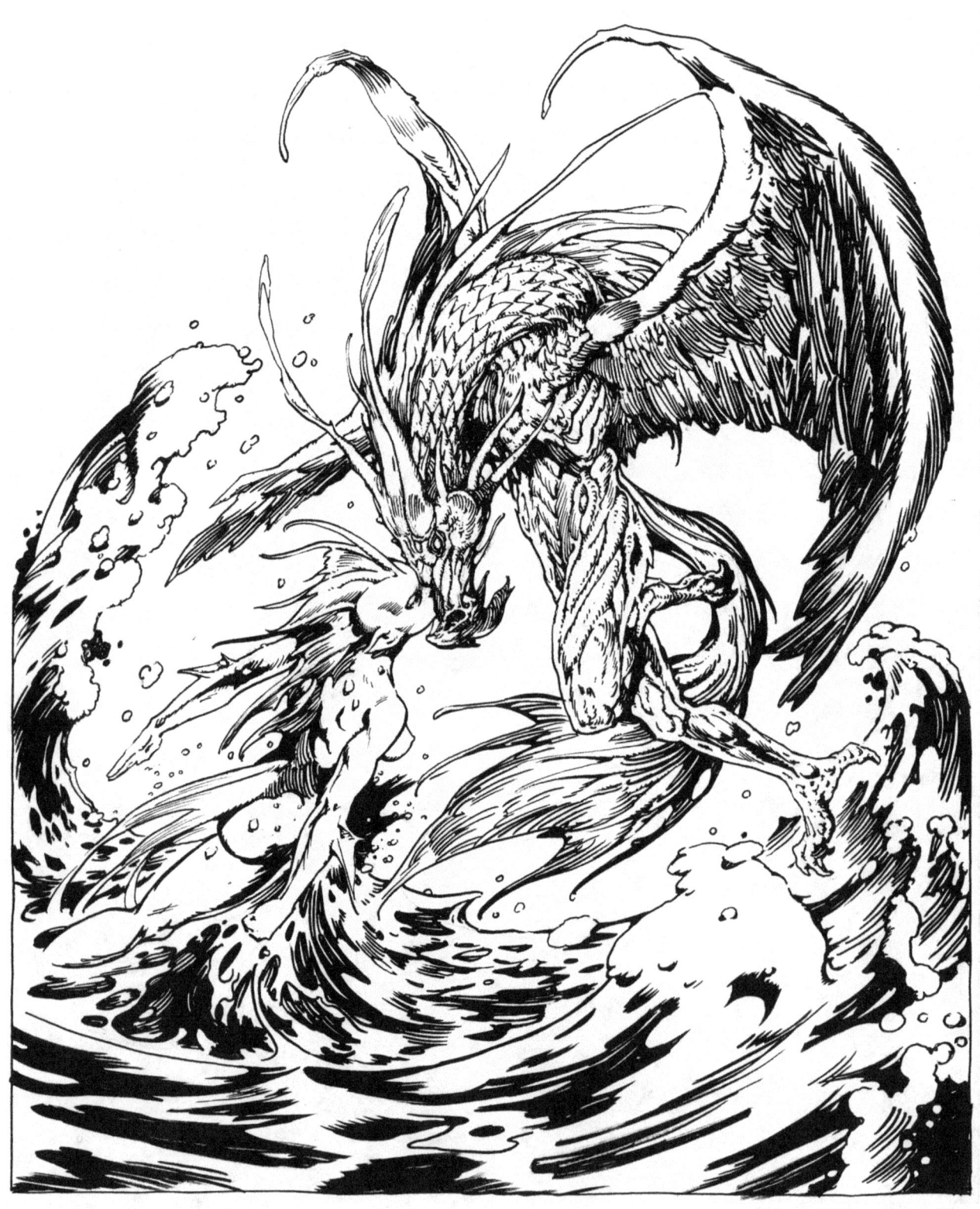

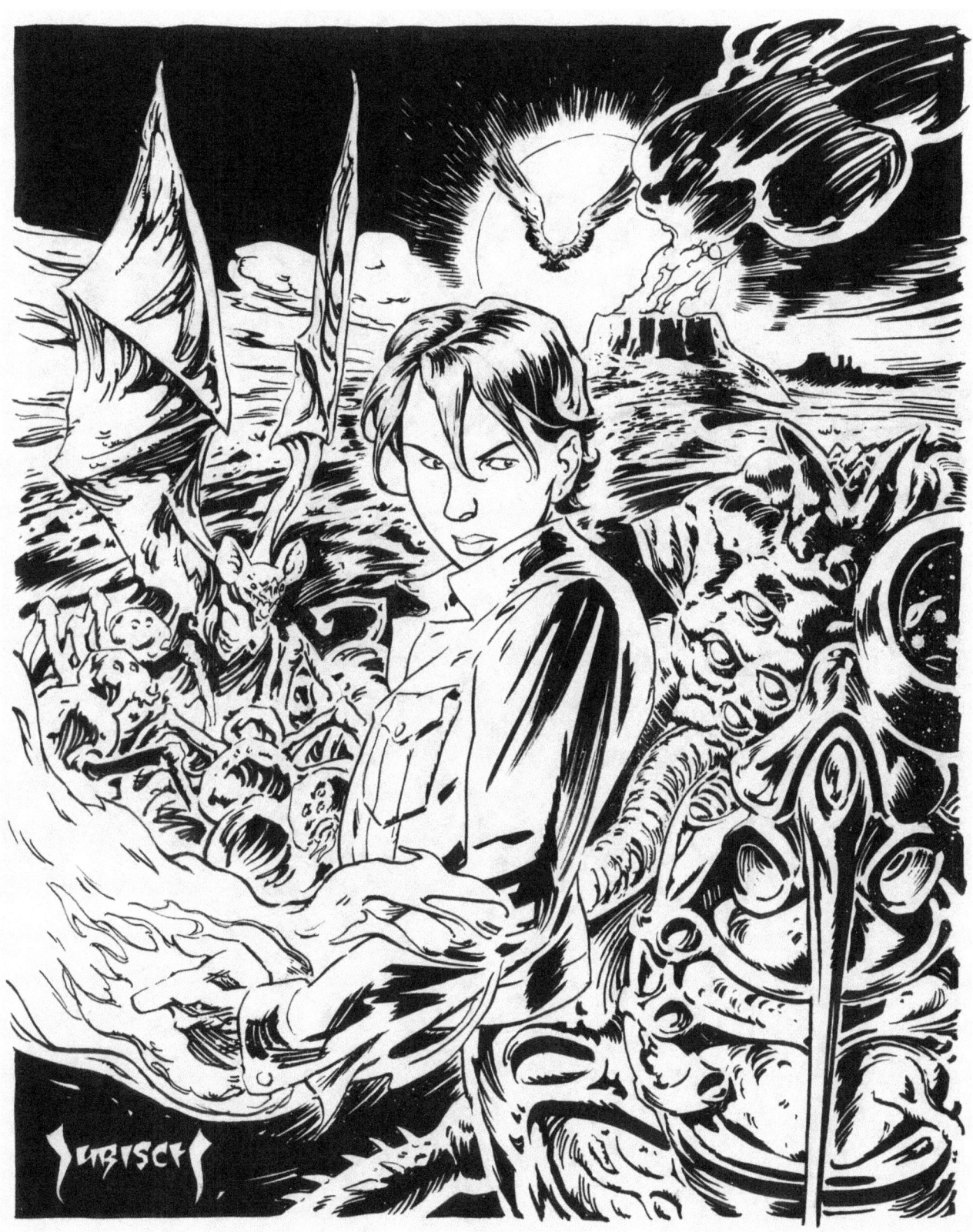

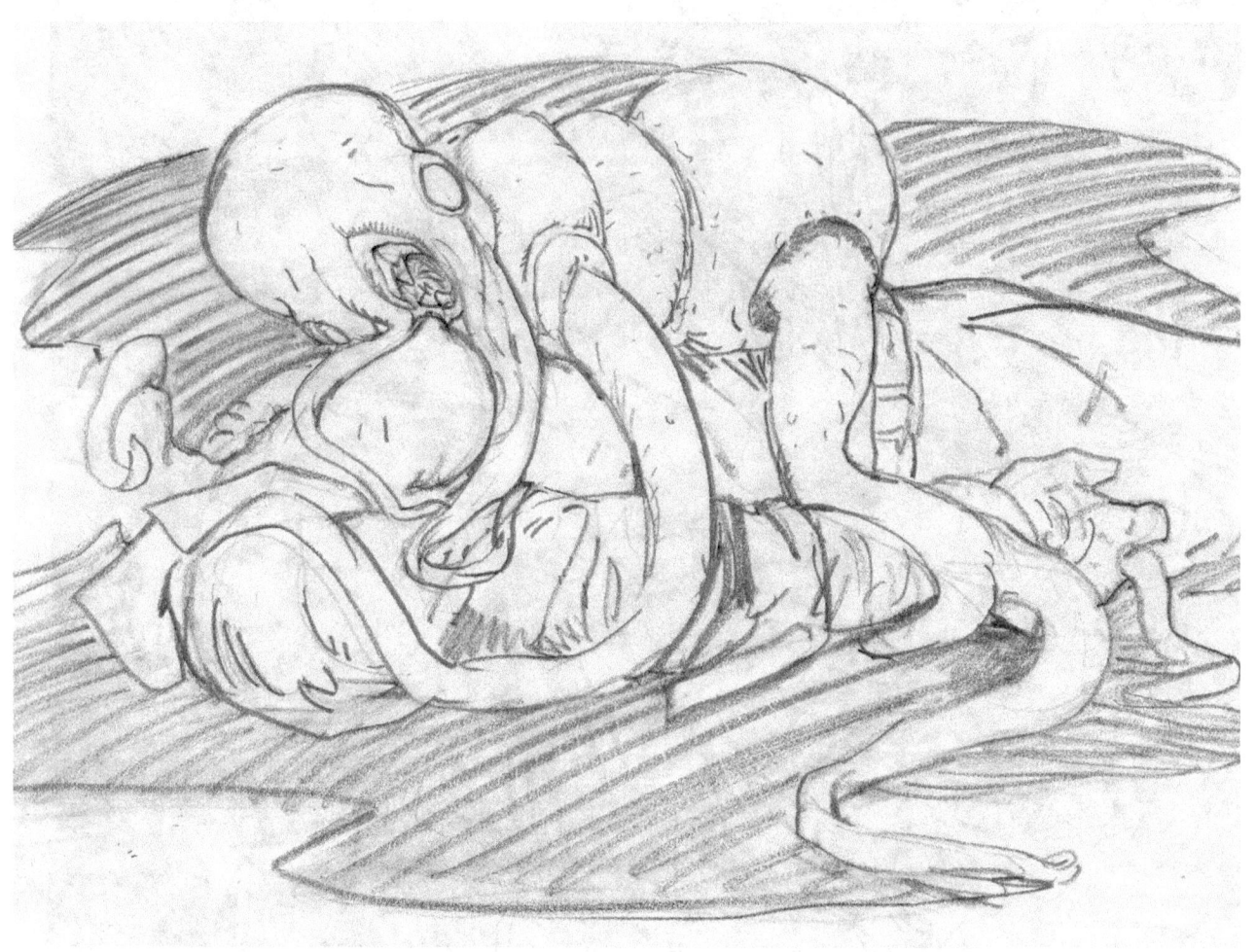

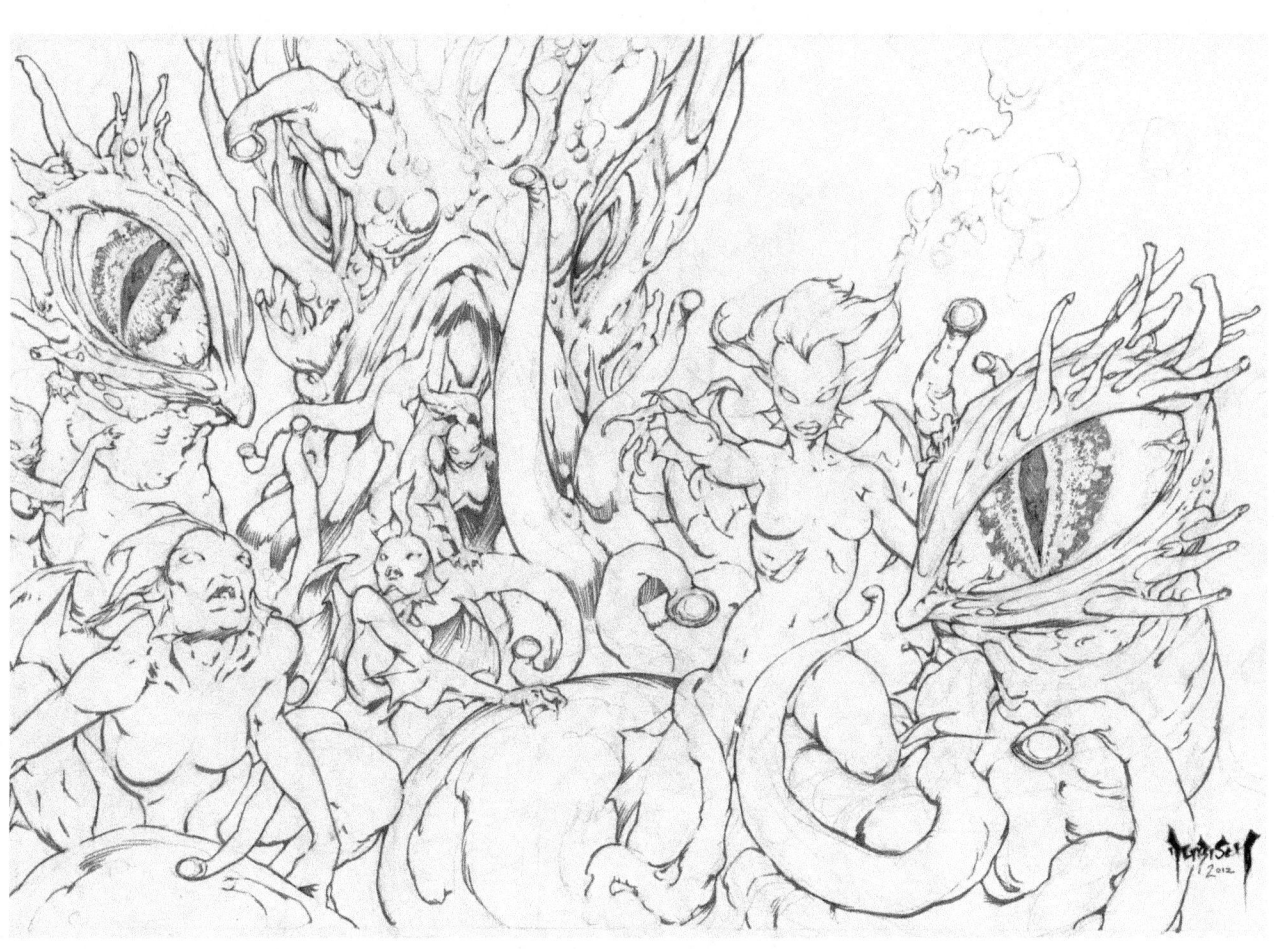

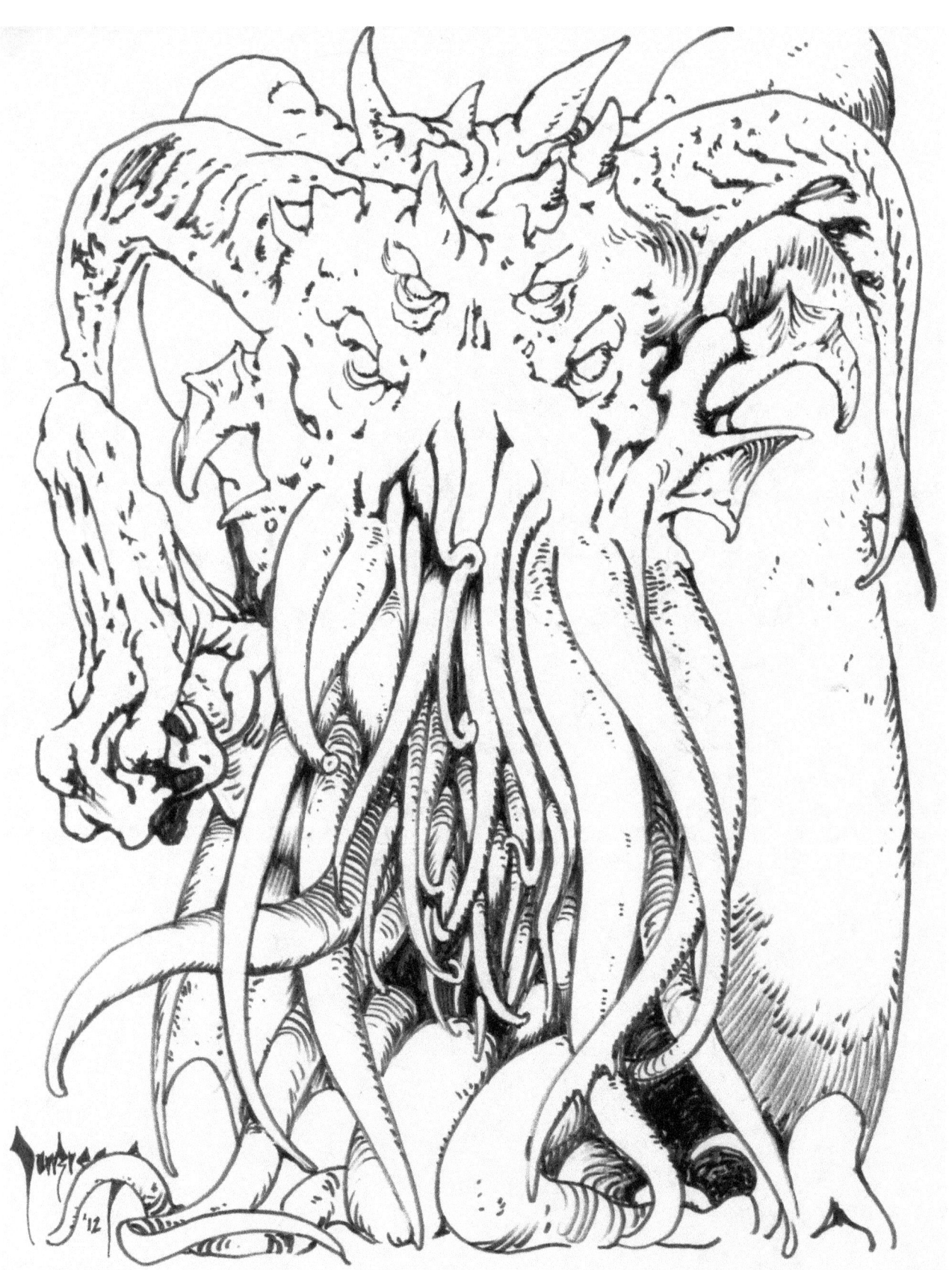

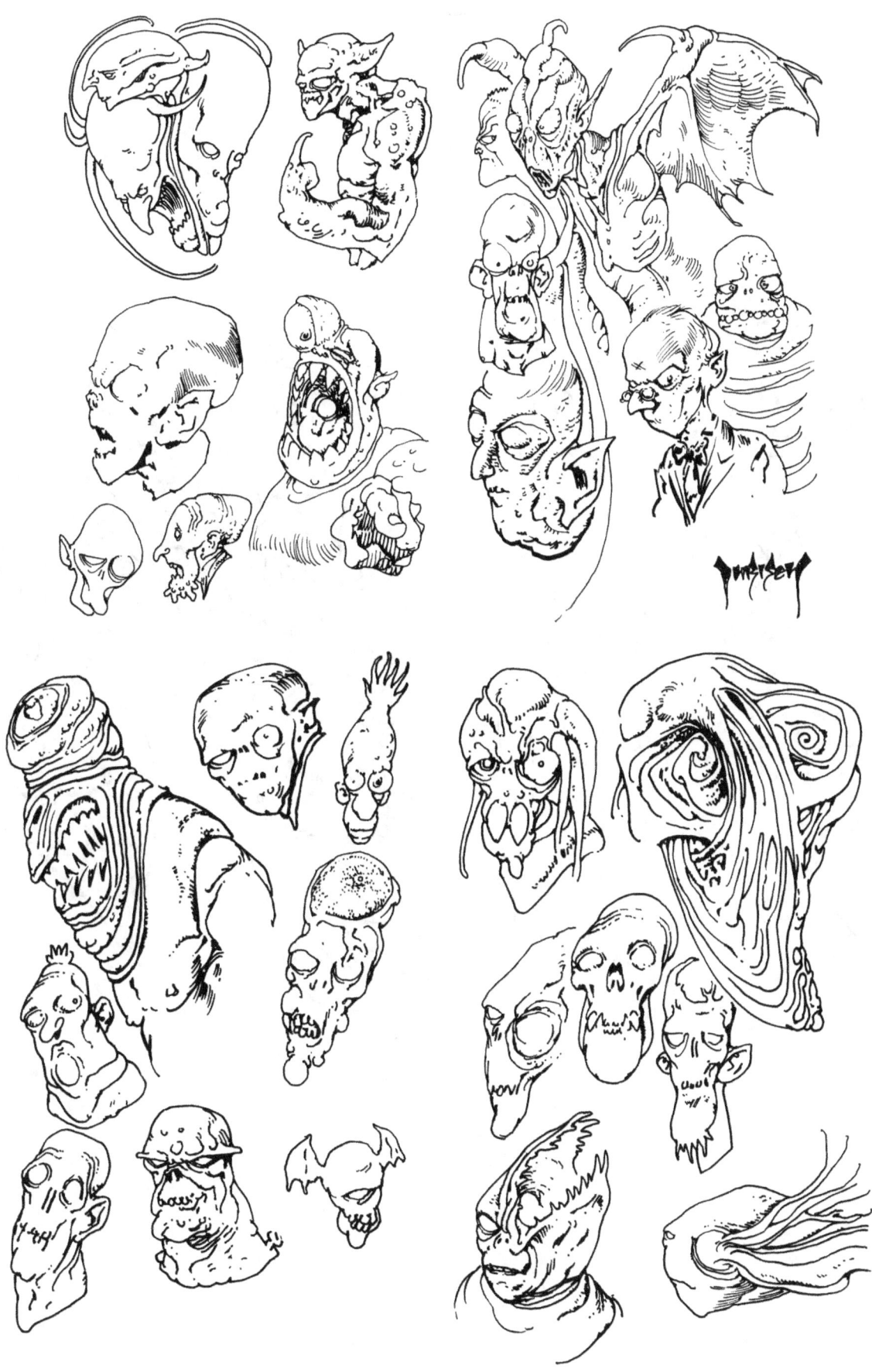

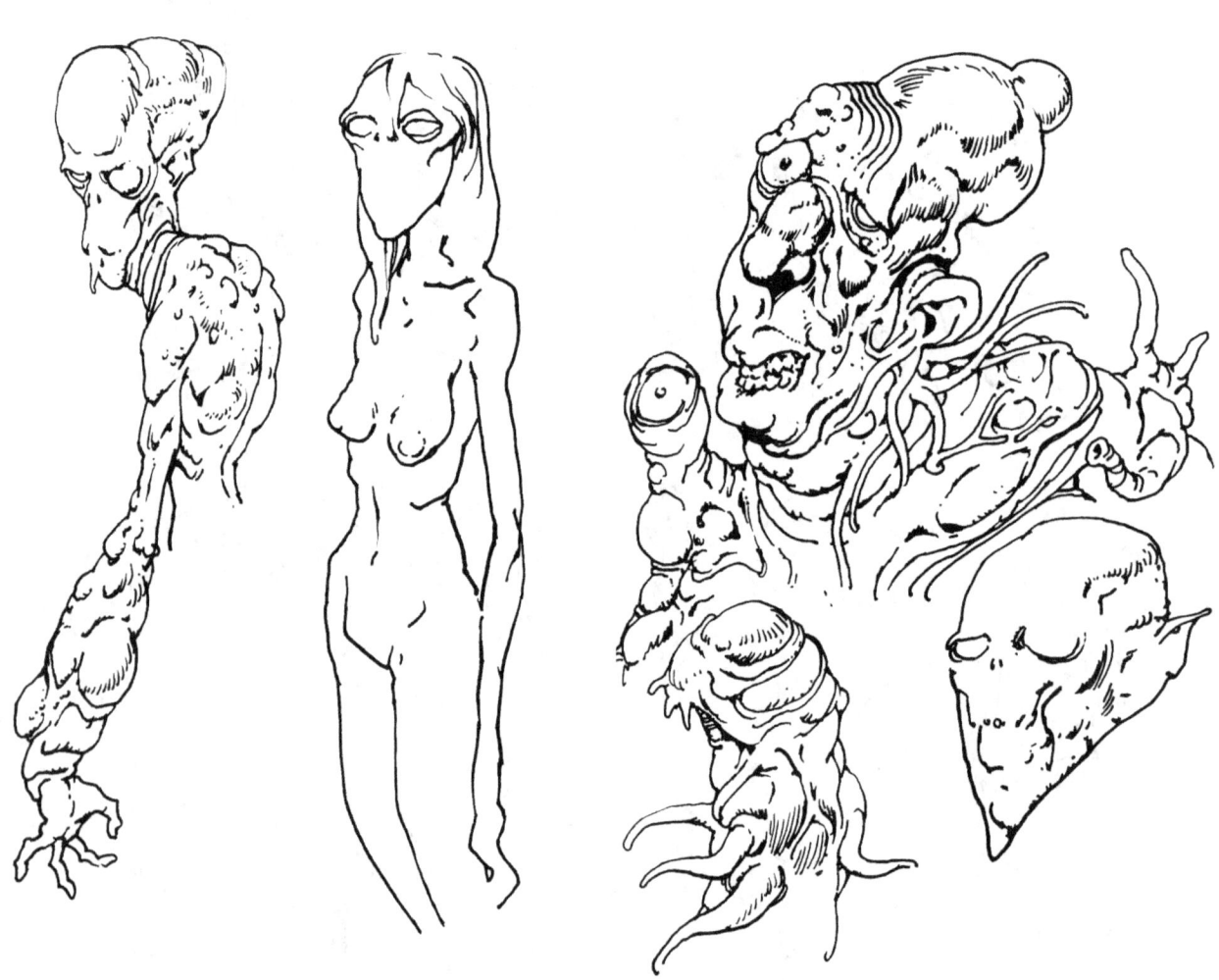

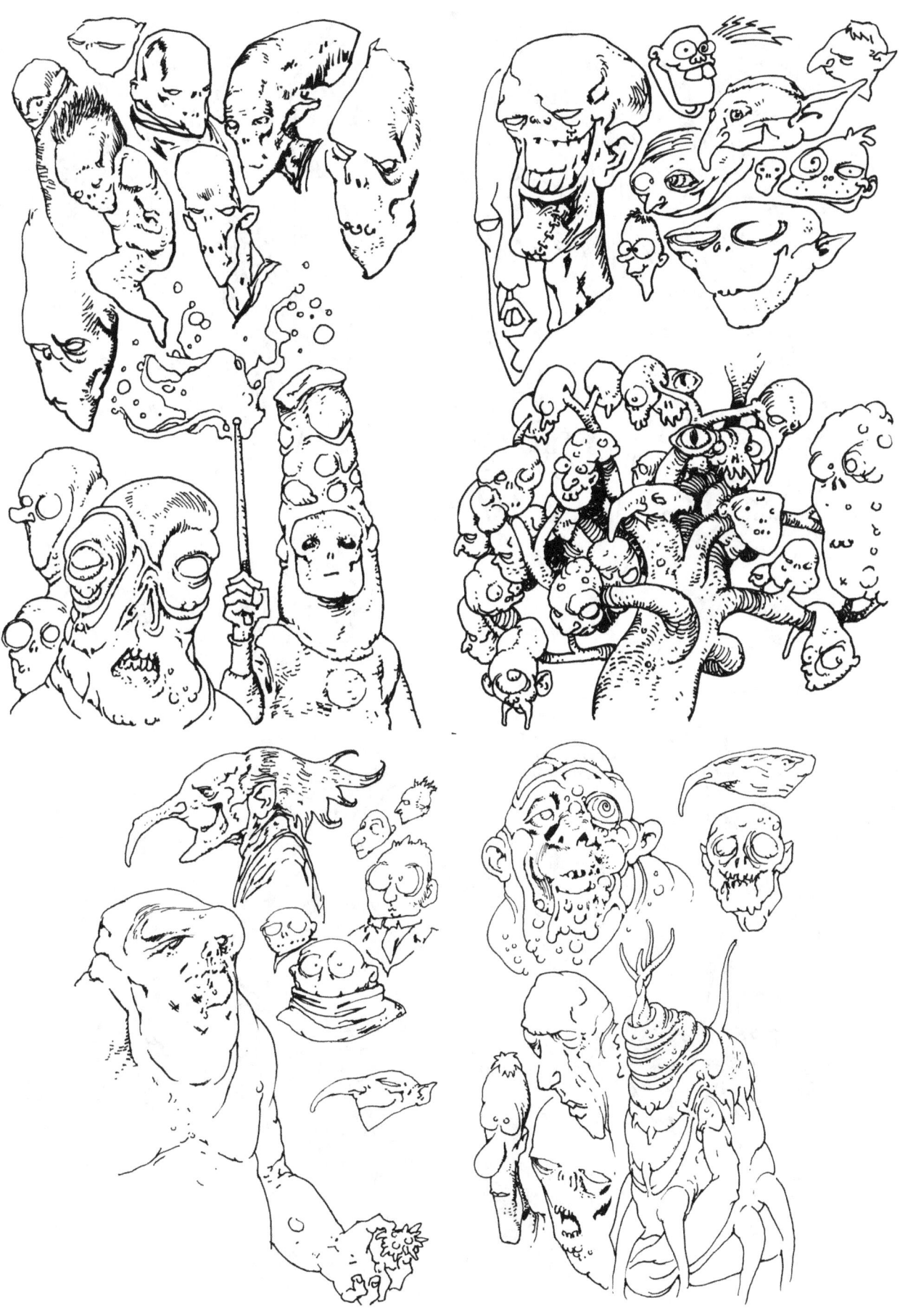

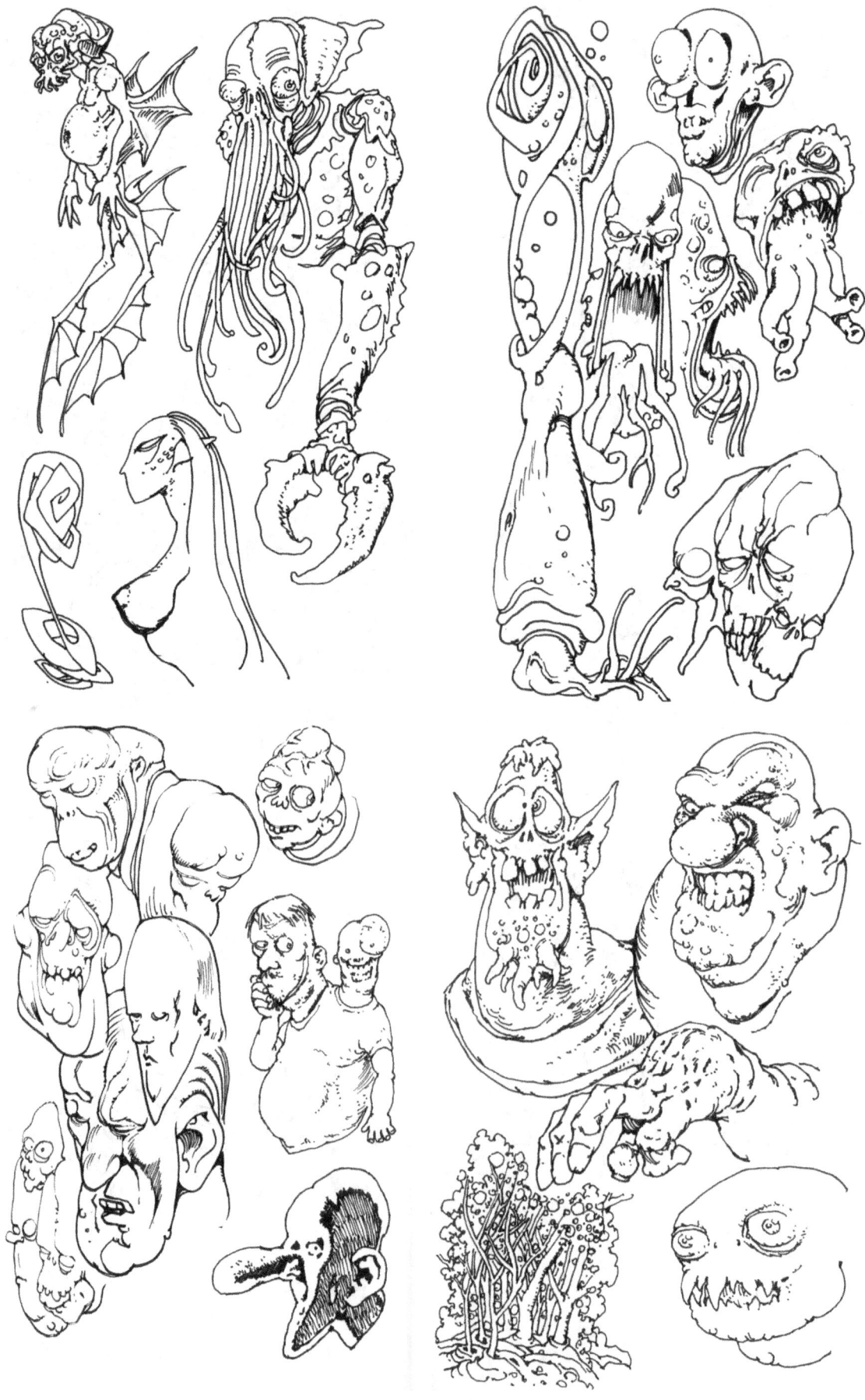

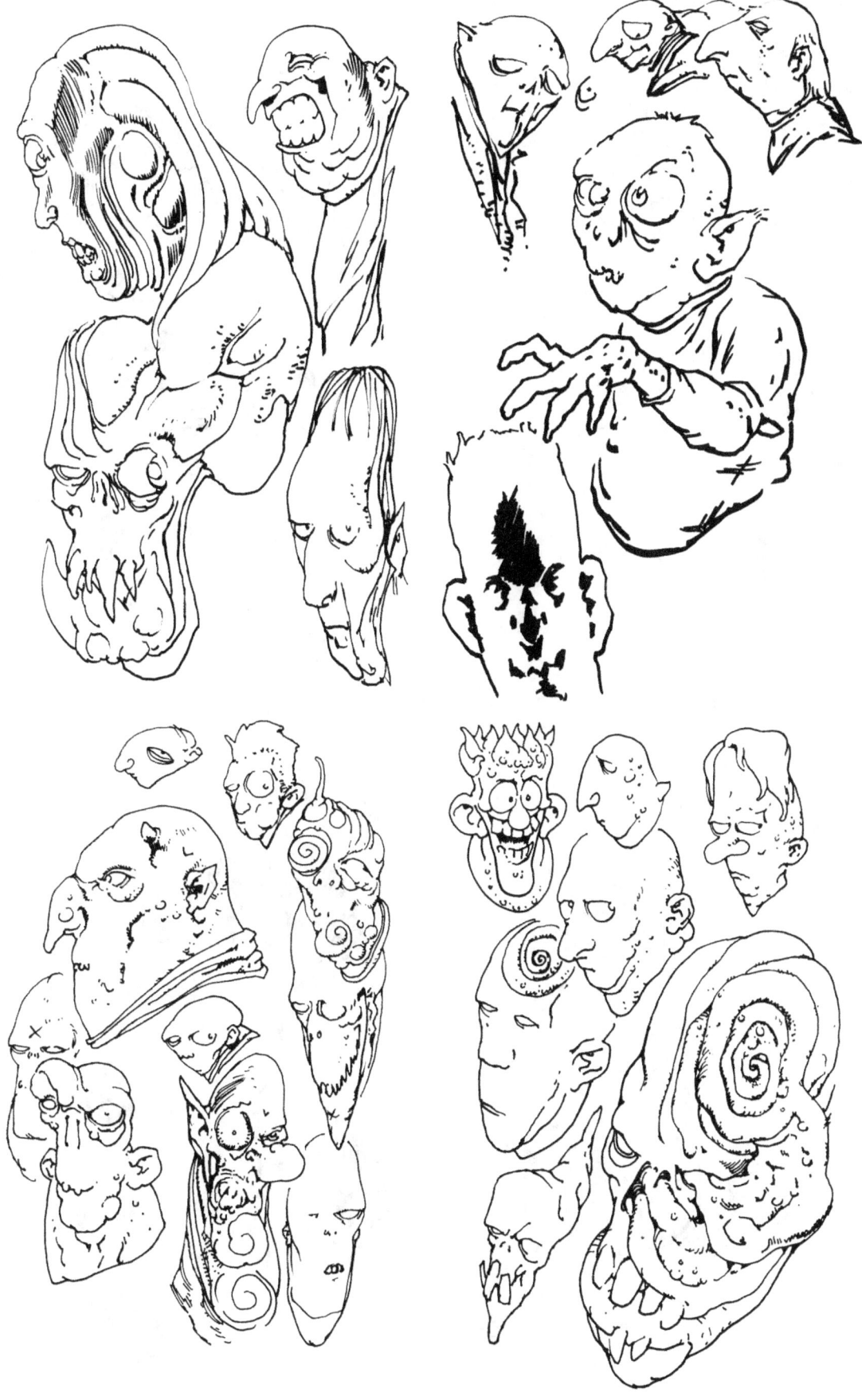

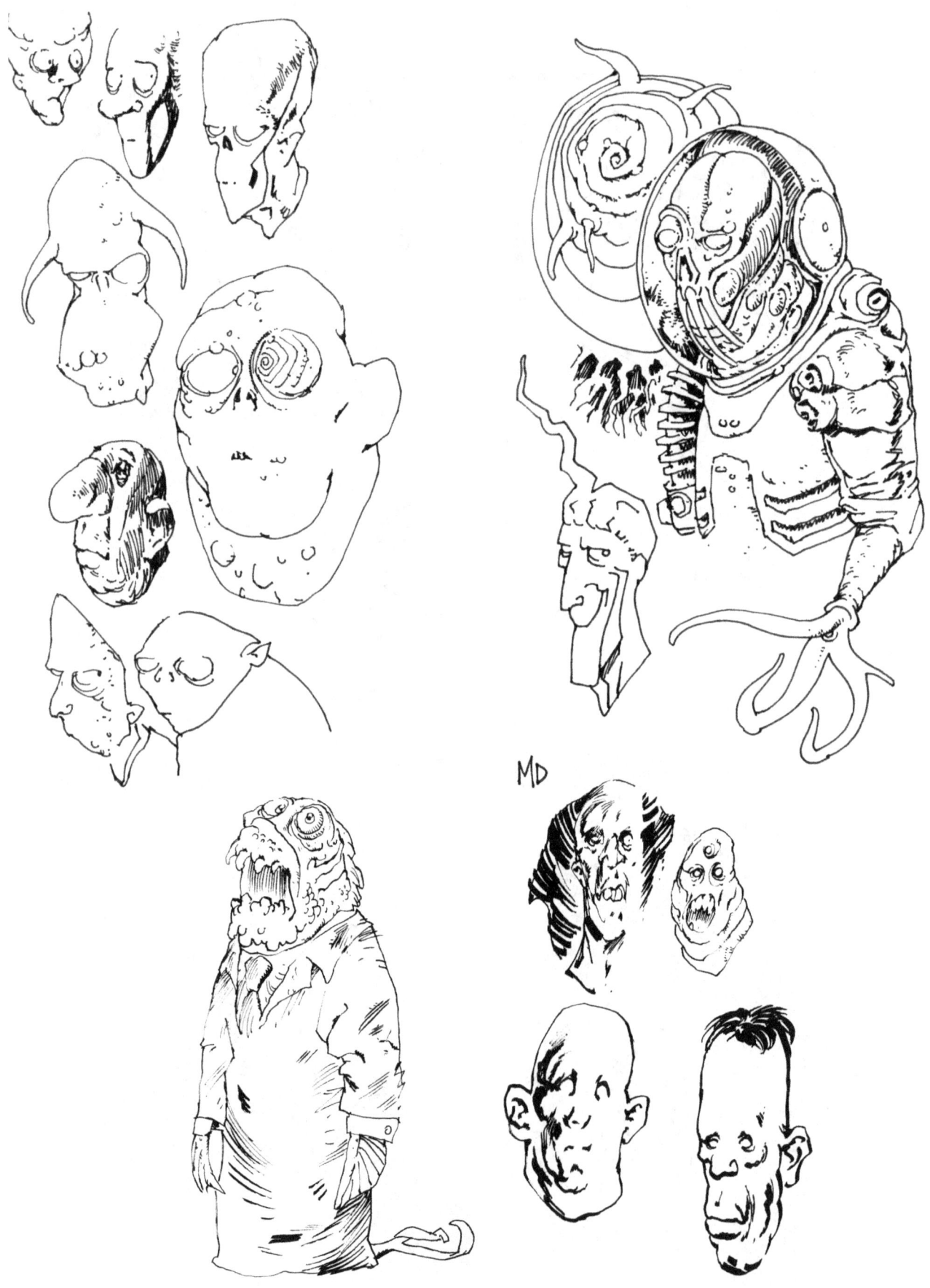

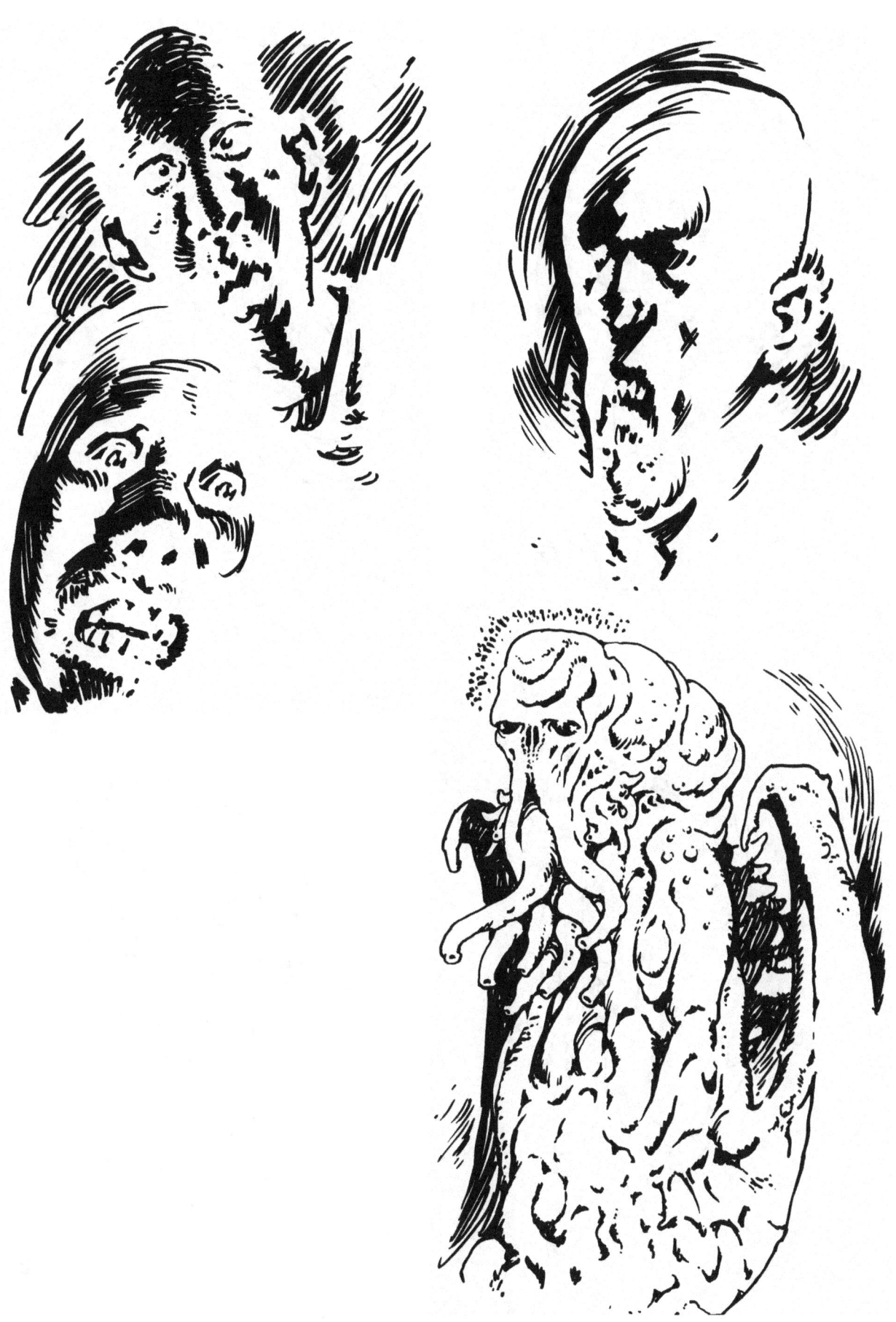

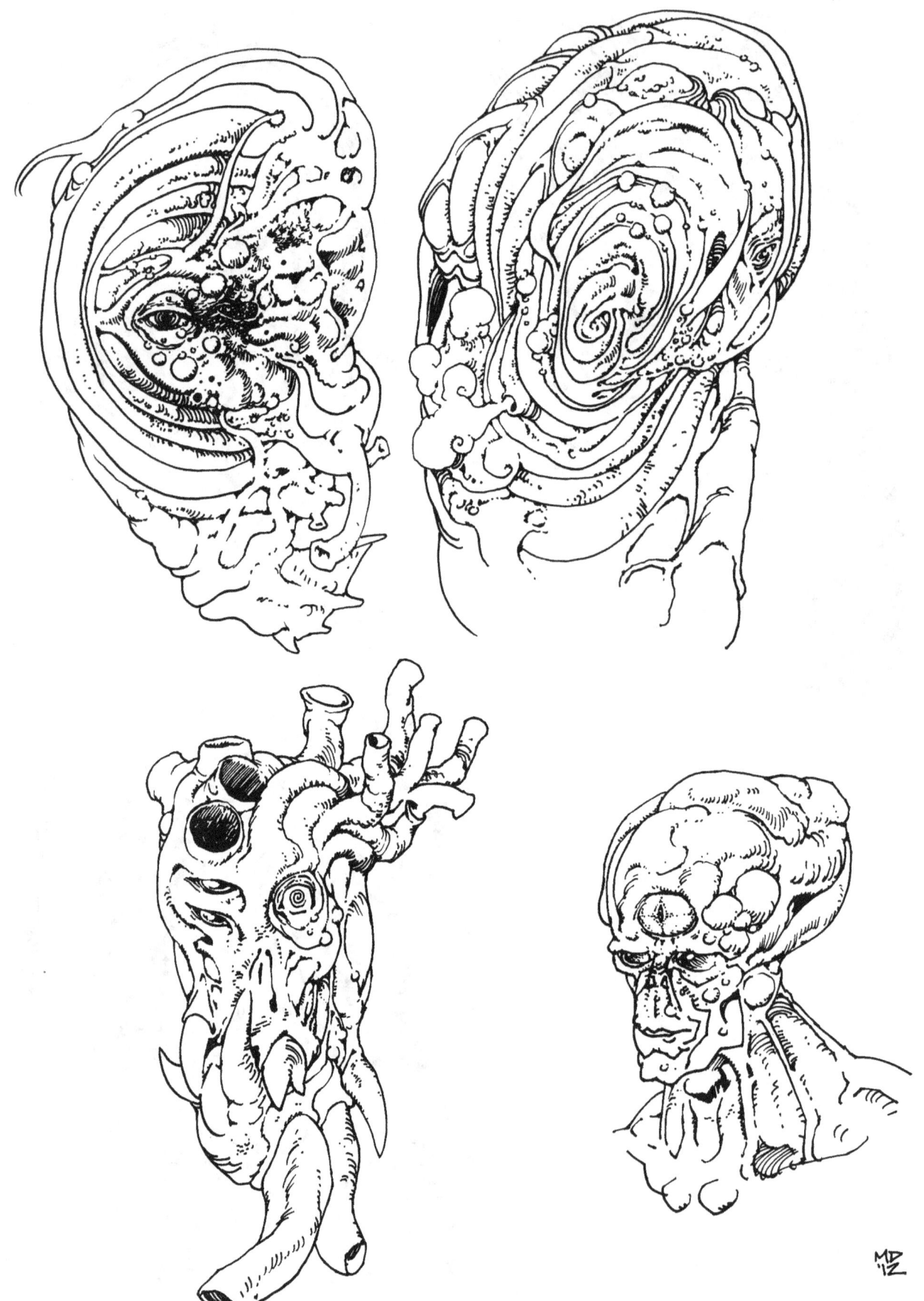

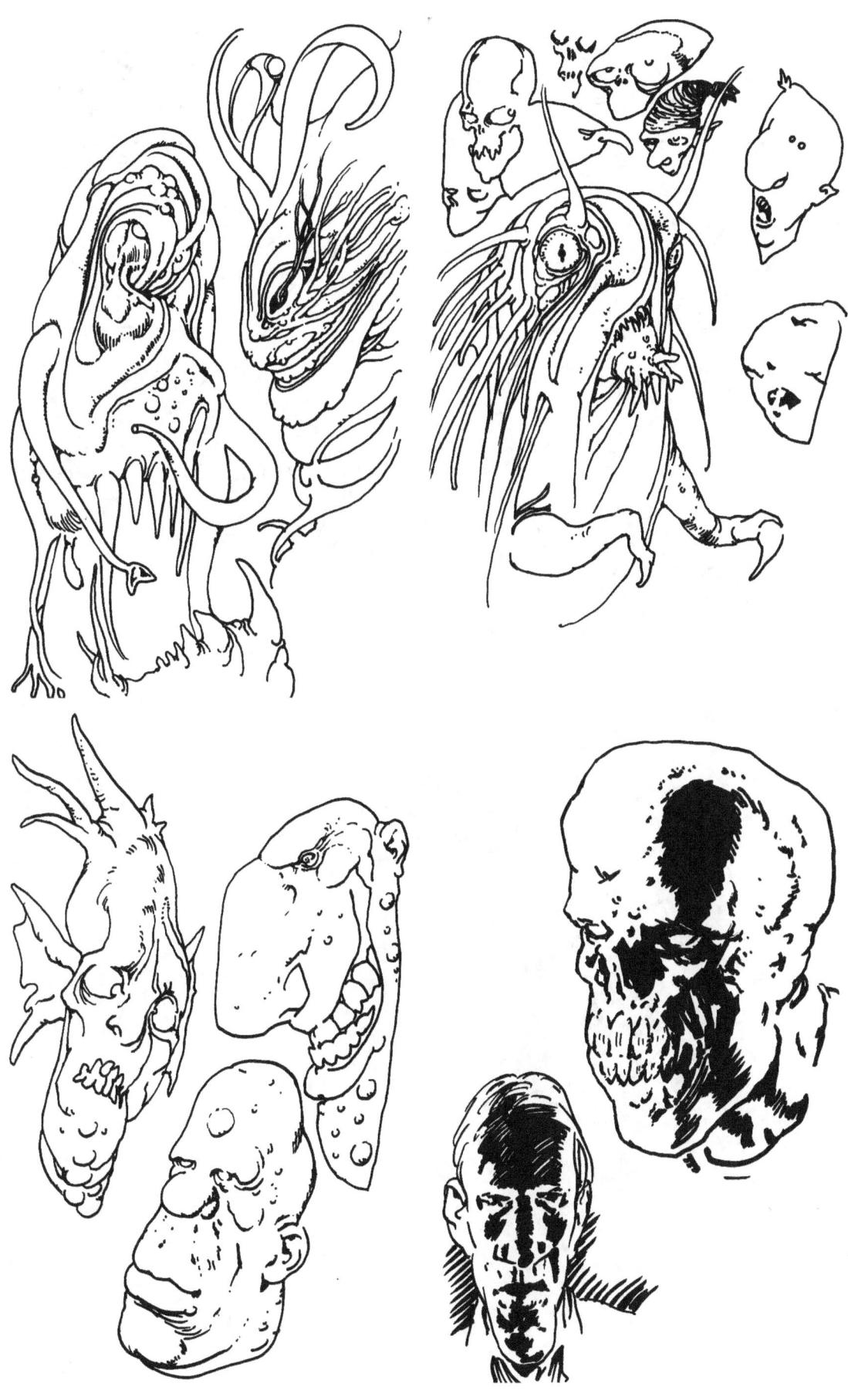

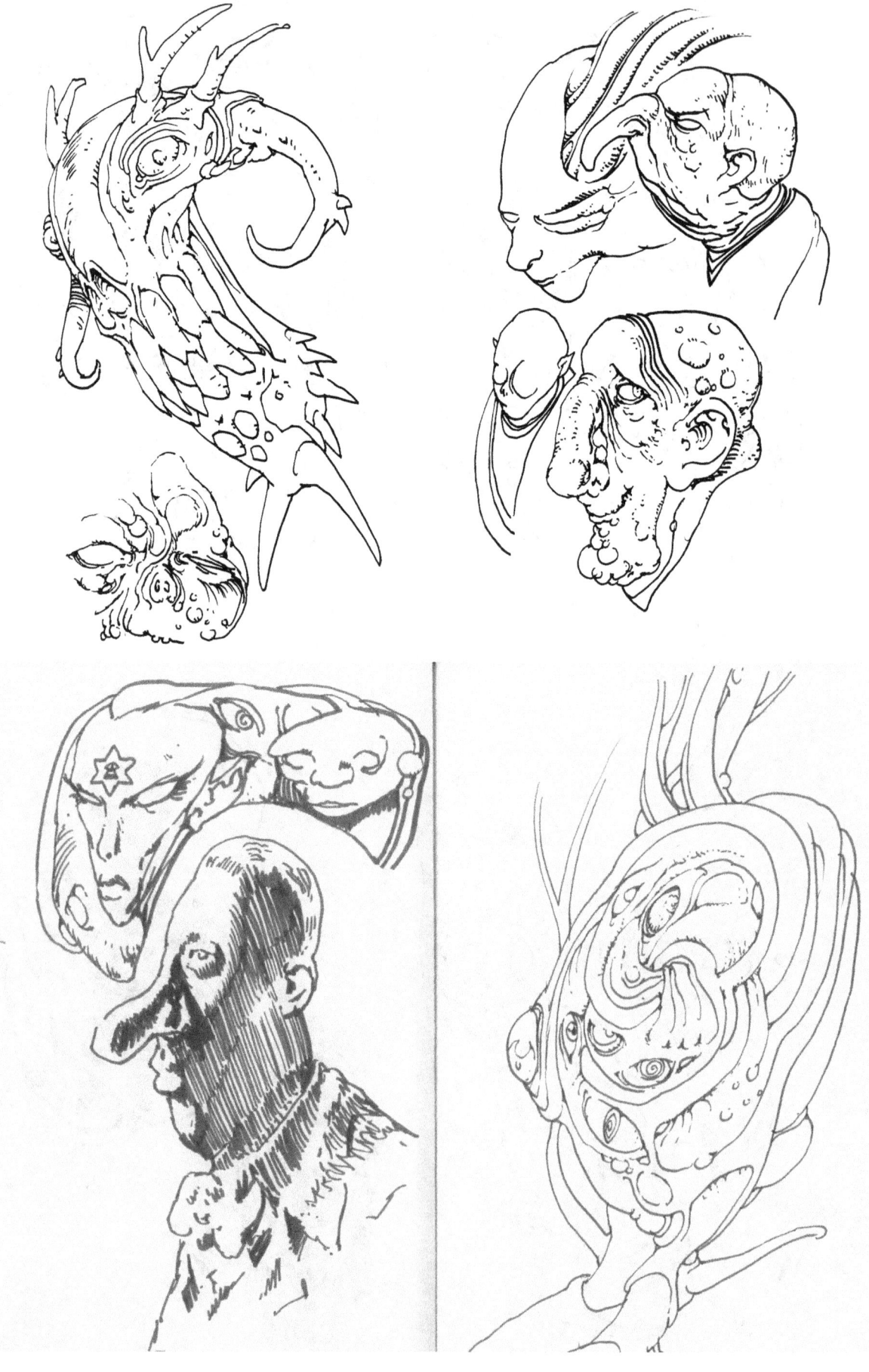

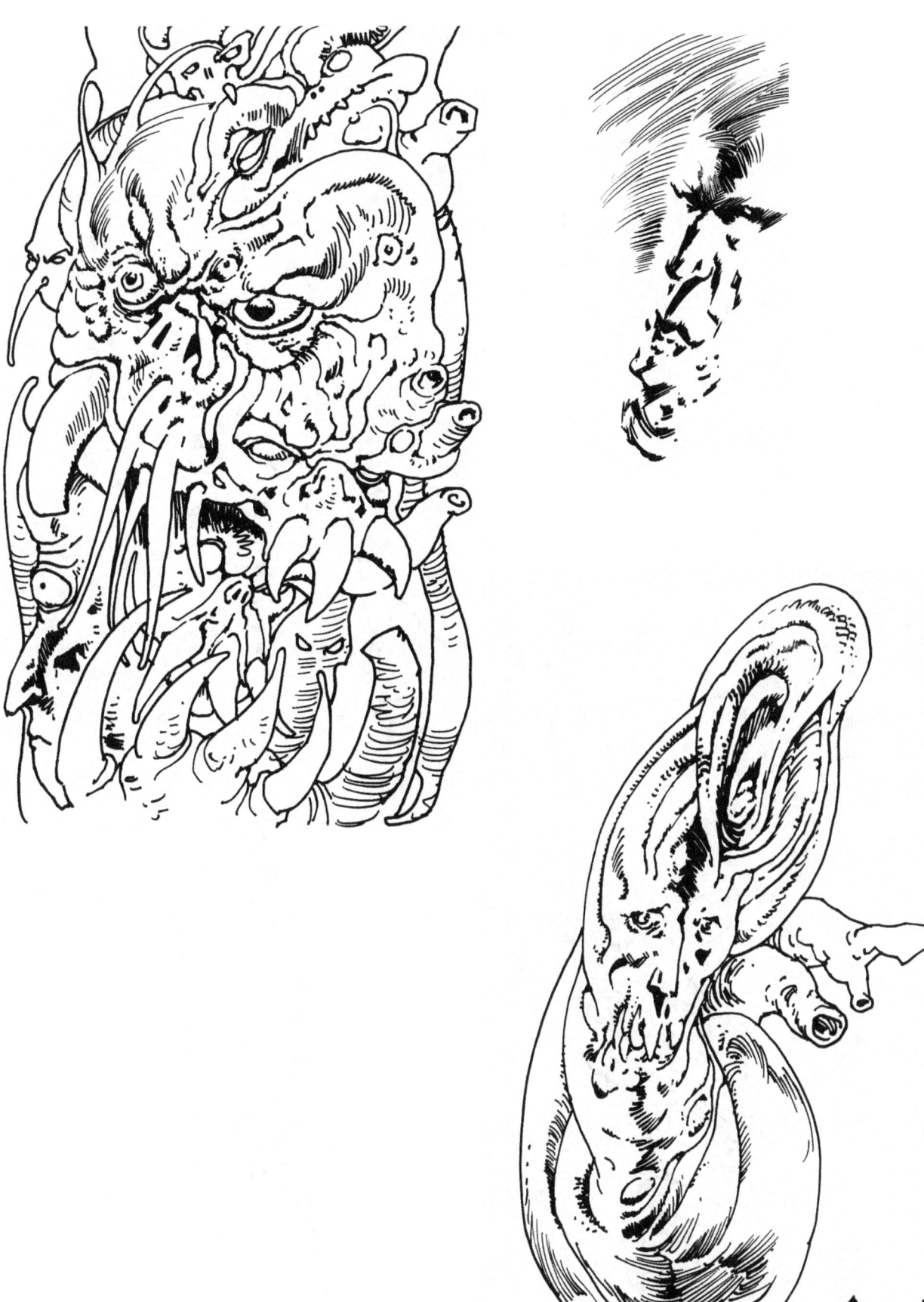

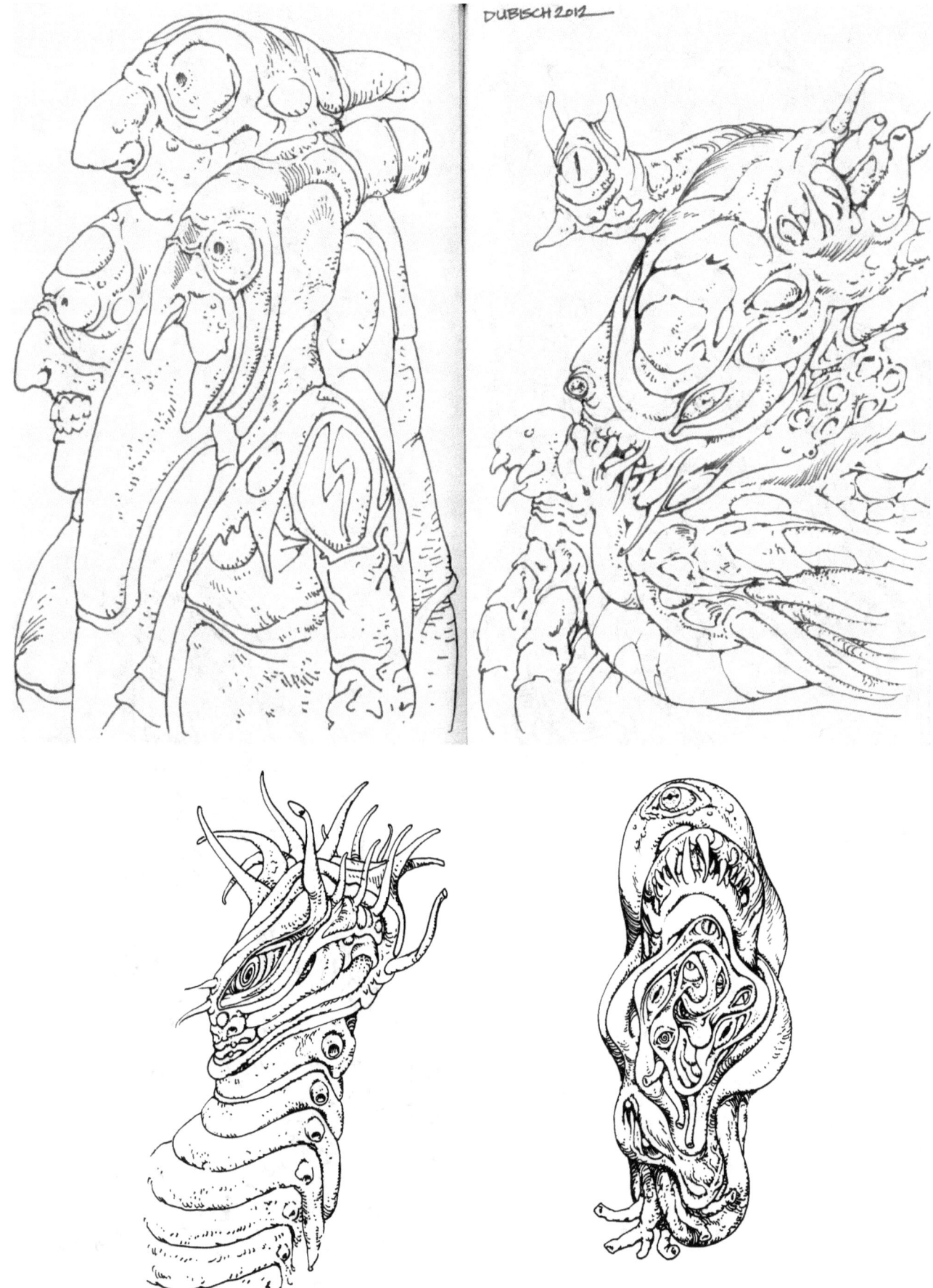

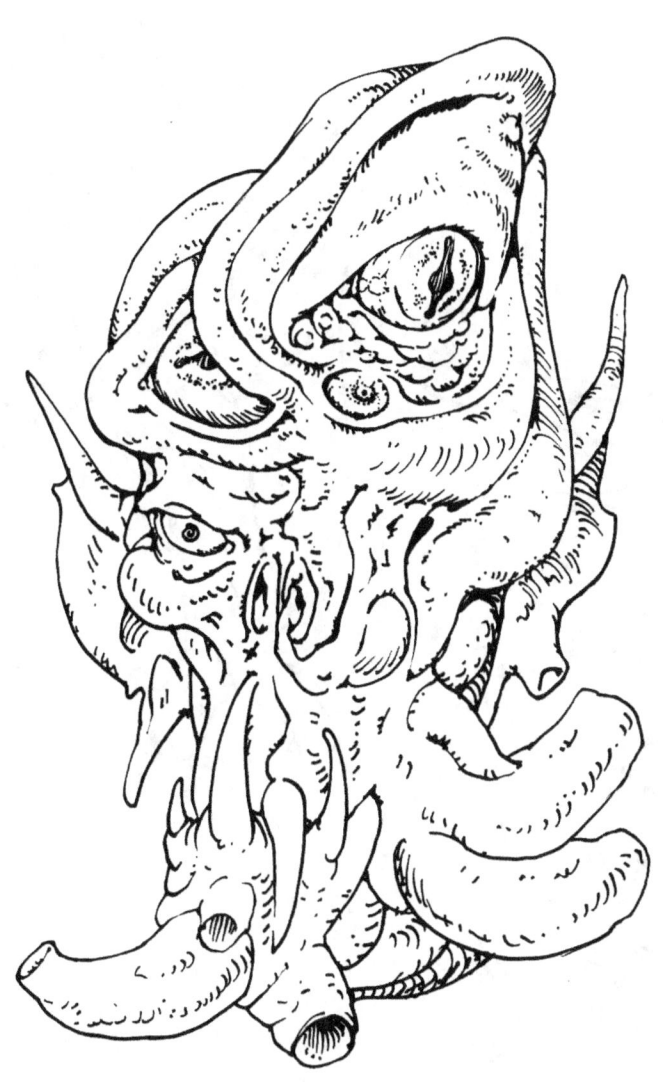

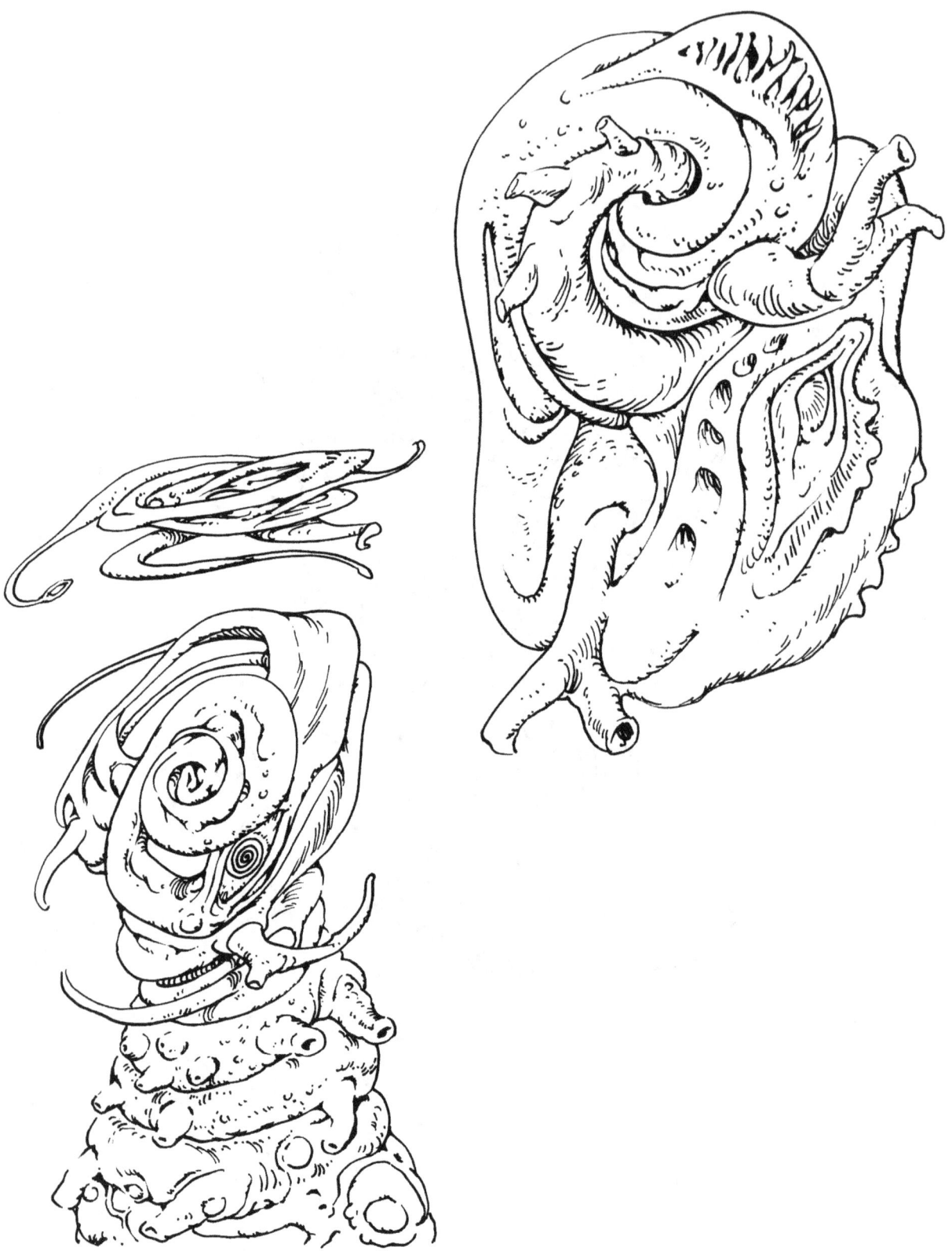

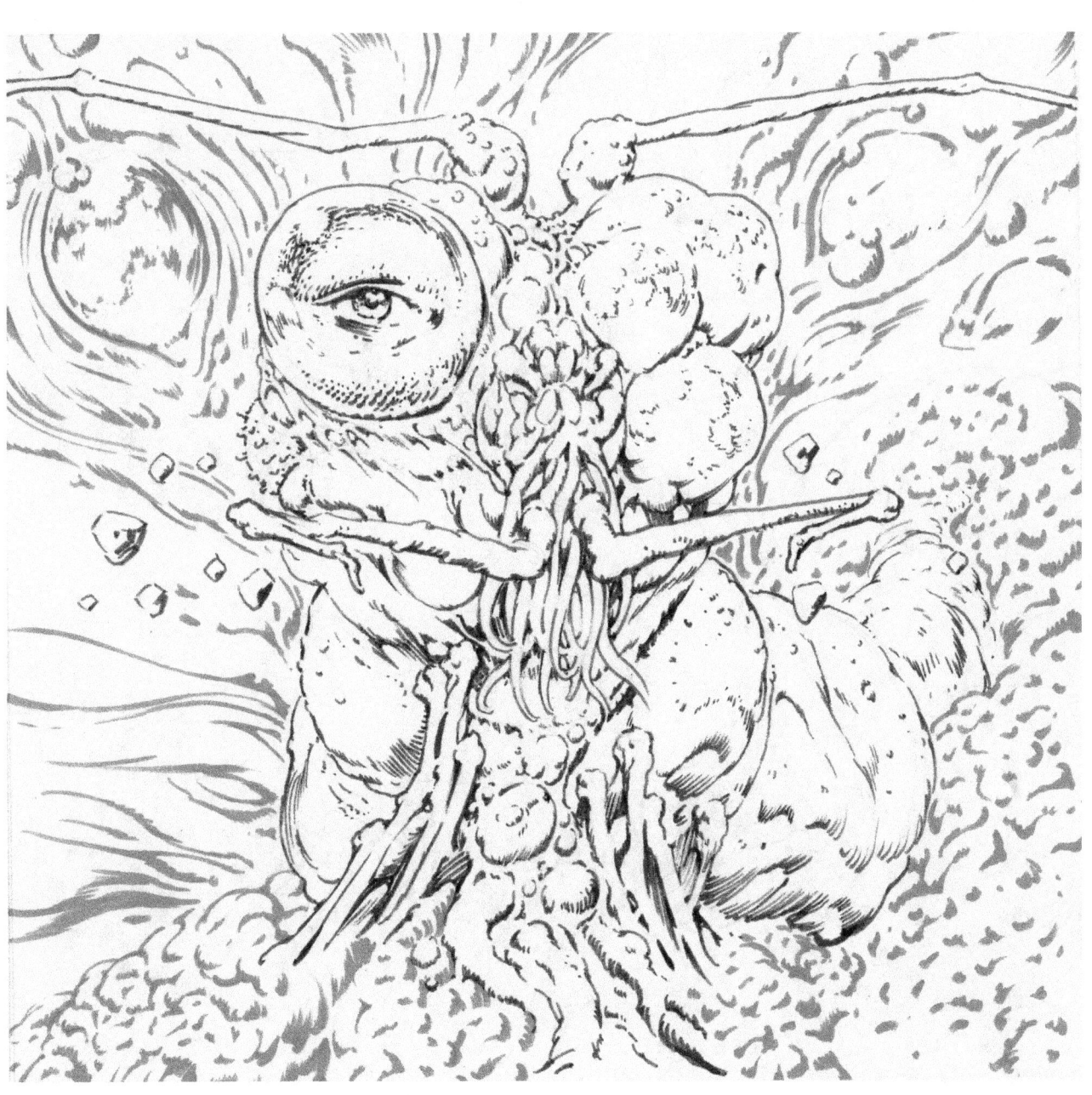

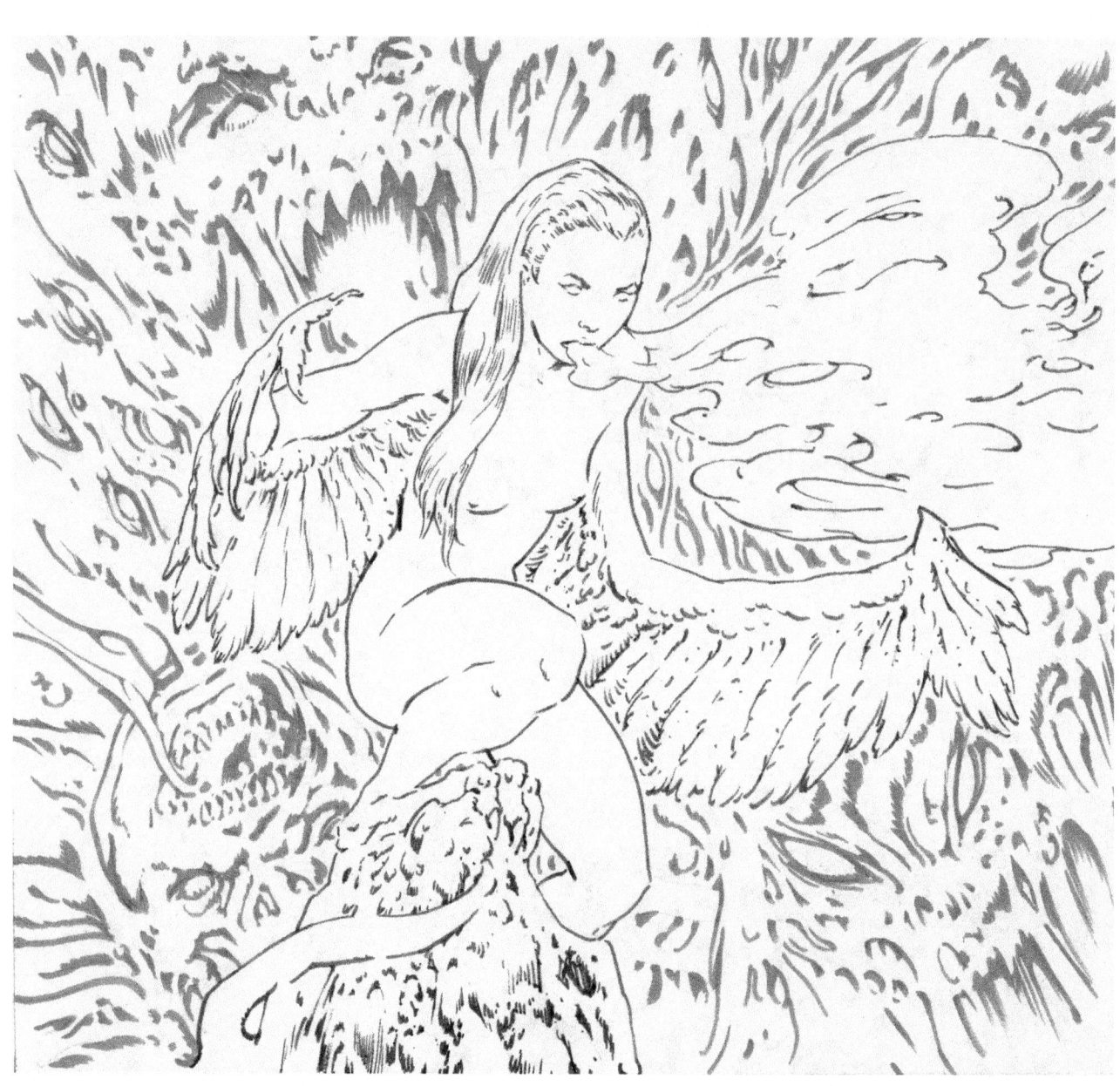

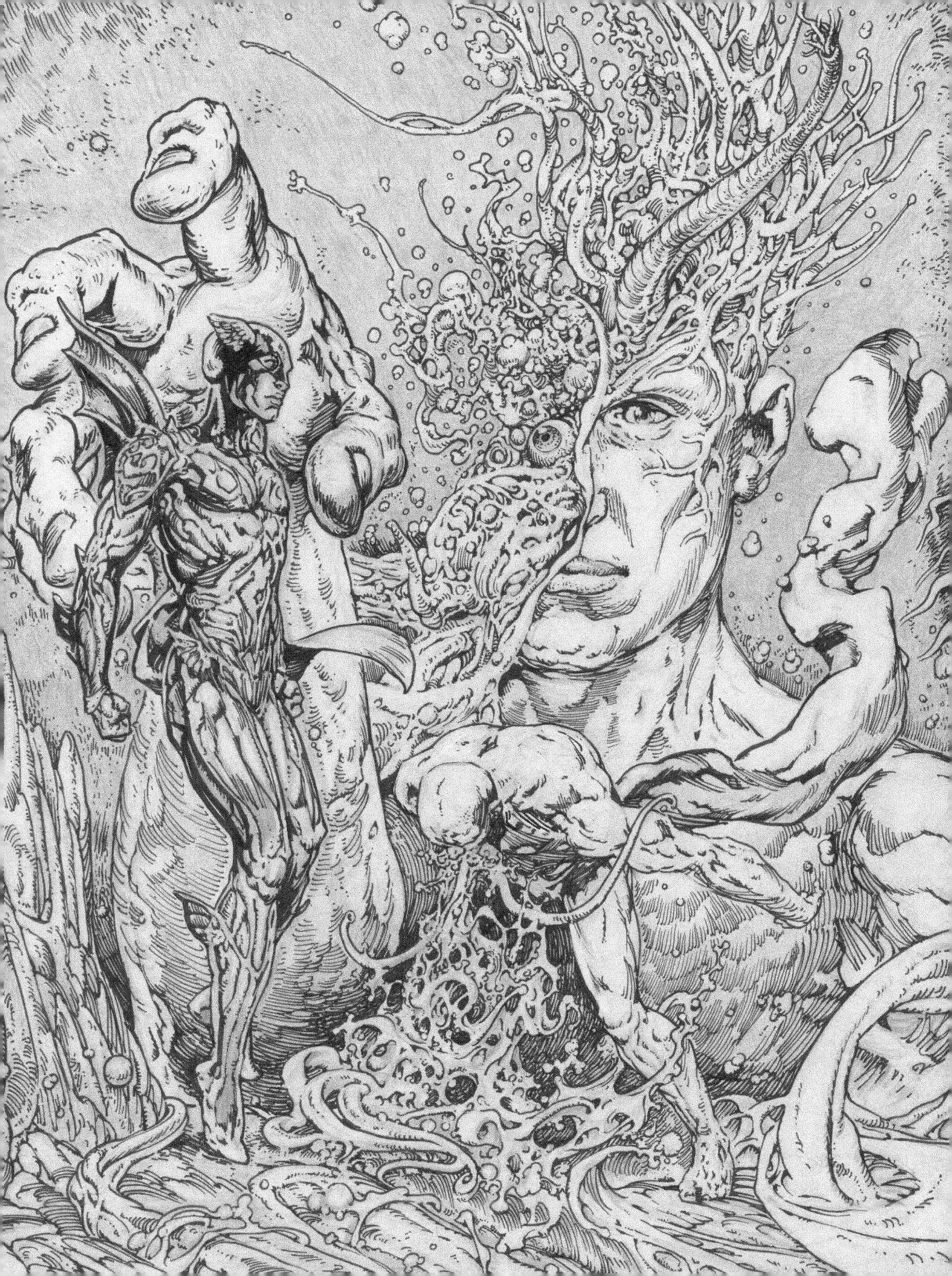

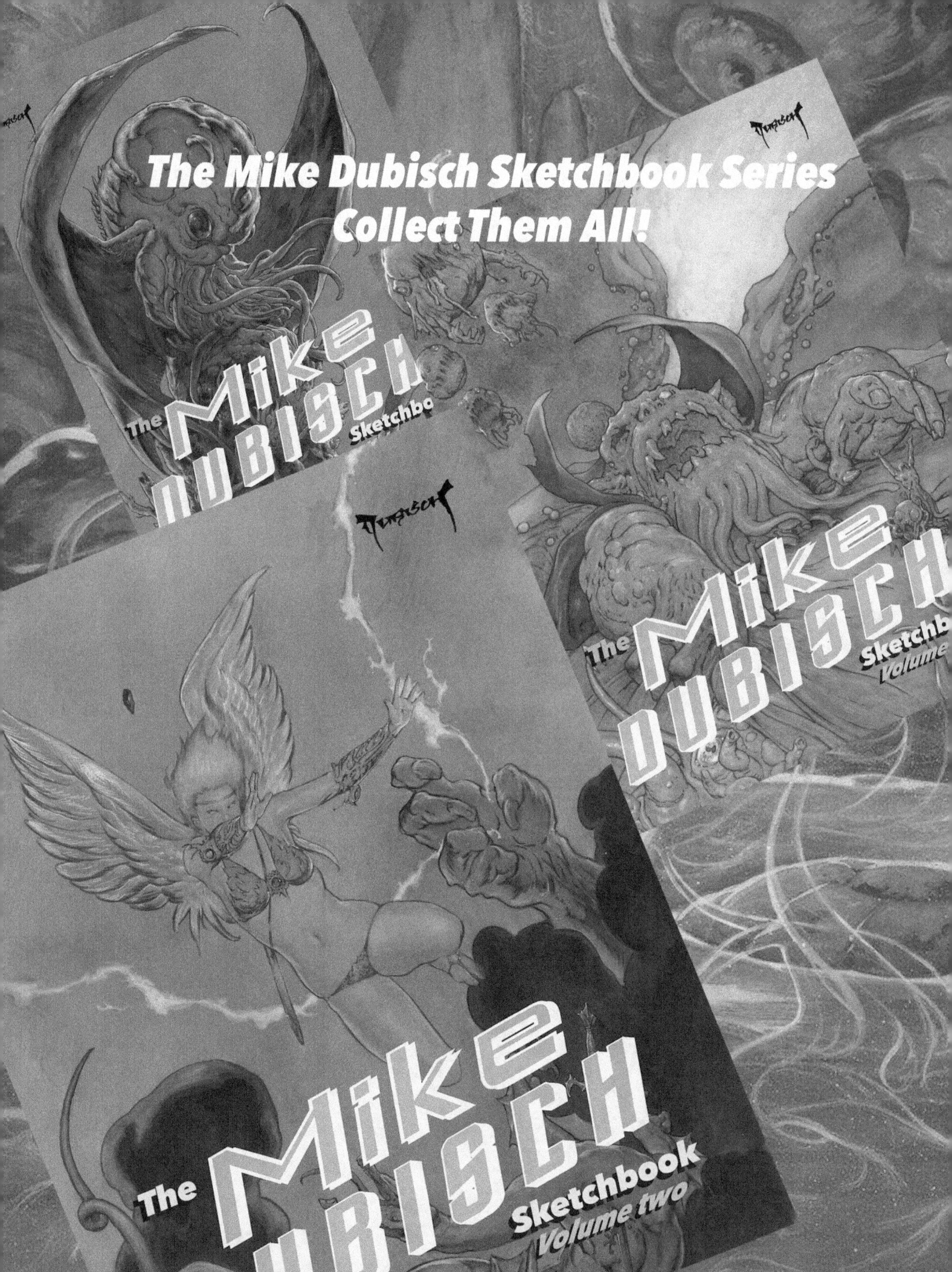

www.ingramcontent.com/pod-product-compliance
Lightning Source LLC
Chambersburg PA
CBHW080826170526
45158CB00009B/2536